Meditative Geometry
Contemplate the Eternal Patterns
A coloring book
By Adrian Avocado Andrejeff

Original Designs
Dedicated to The Good Nature Inside All Life and You
Images are copyrighted
2016

Pattern Recognition is Intelligence and Peace.
Geometry is the pattern in each little piece.
Good decisions based in freedom and creativity,
Flow forth from wisdom gained in geometry.

Color yourself in a space that's safe that you create,
With your deepest truths to communicate.
Bend the colors of the rainbow to express how you feel,
And from this place make your best dreams real.

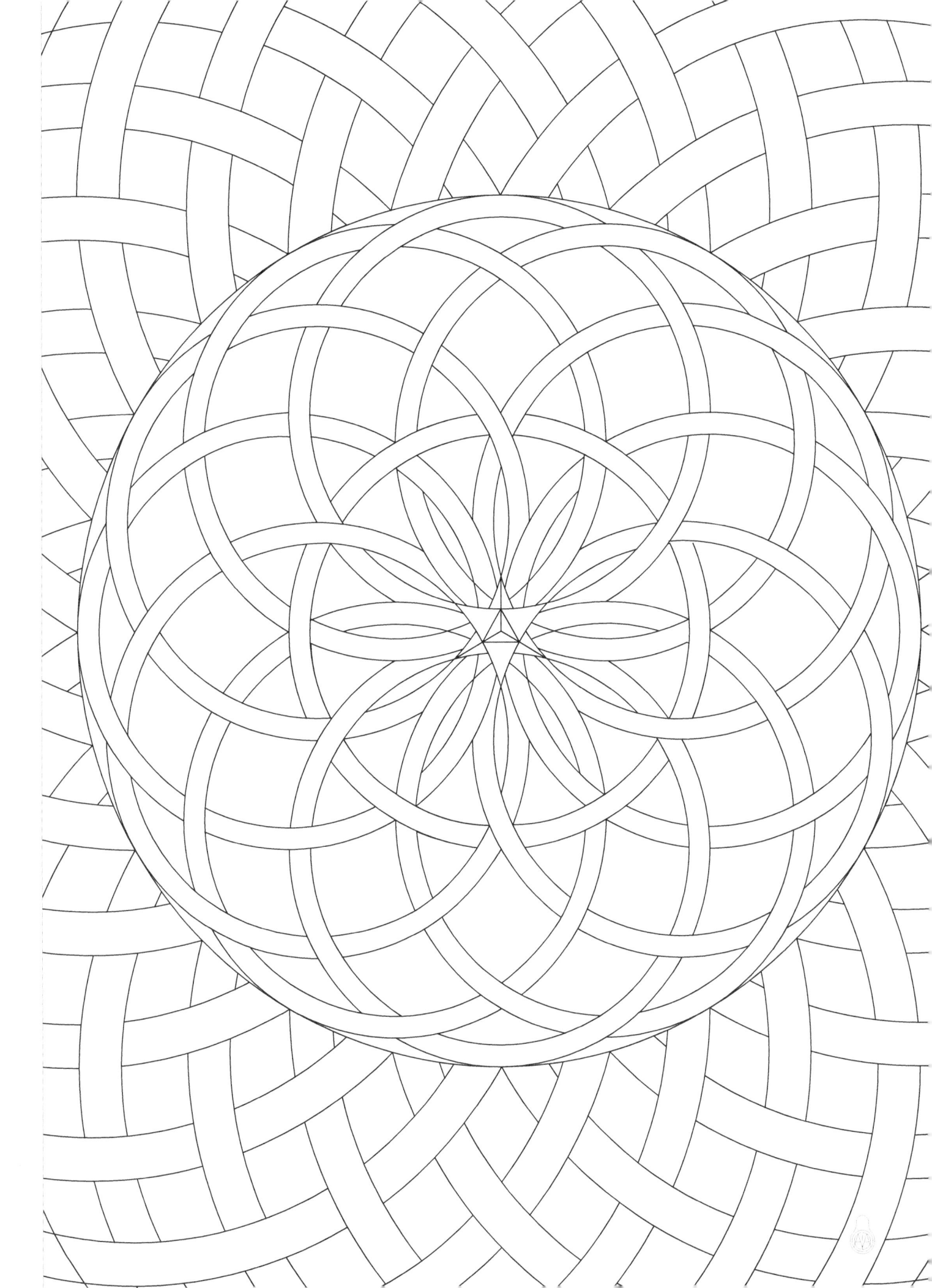

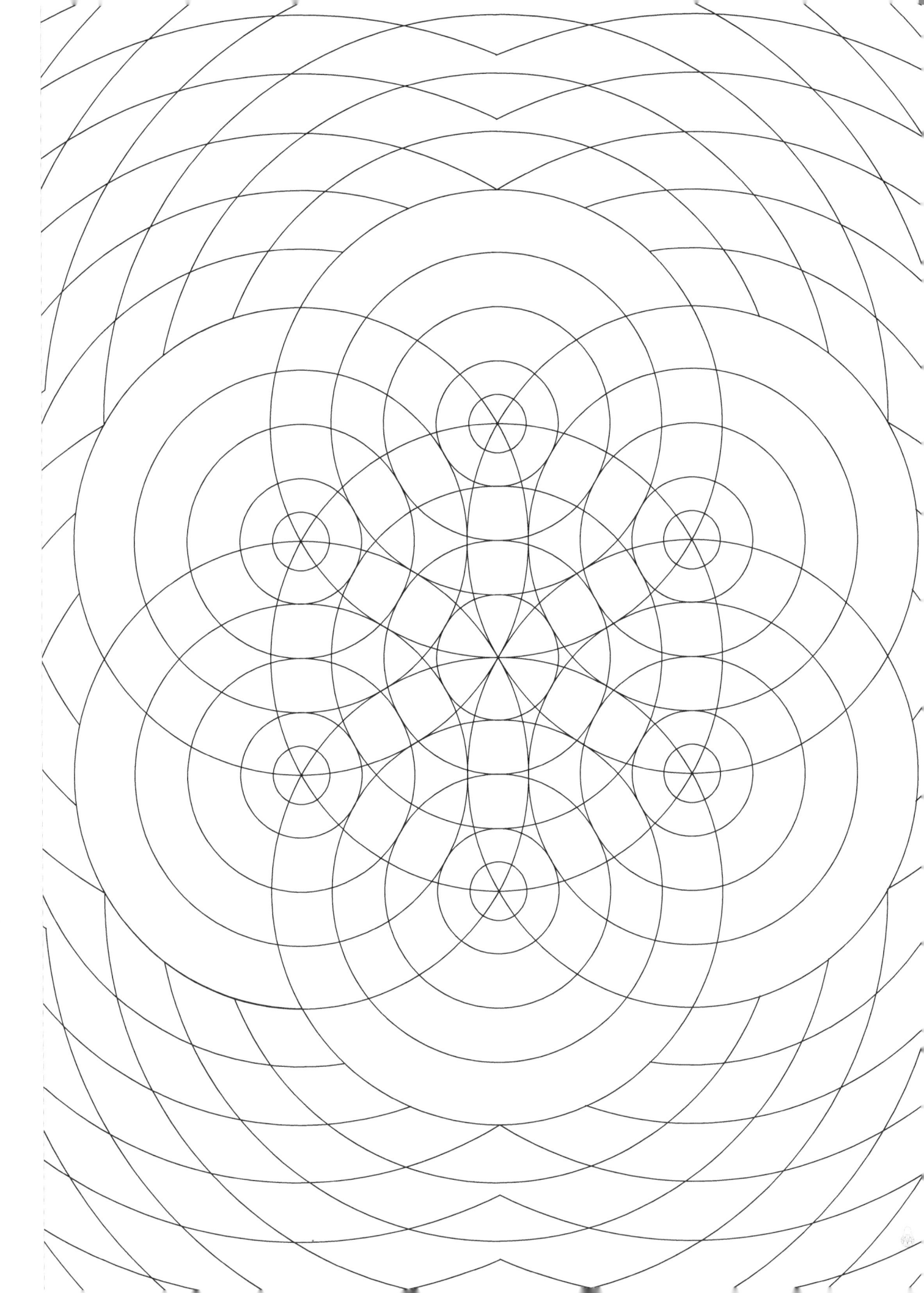

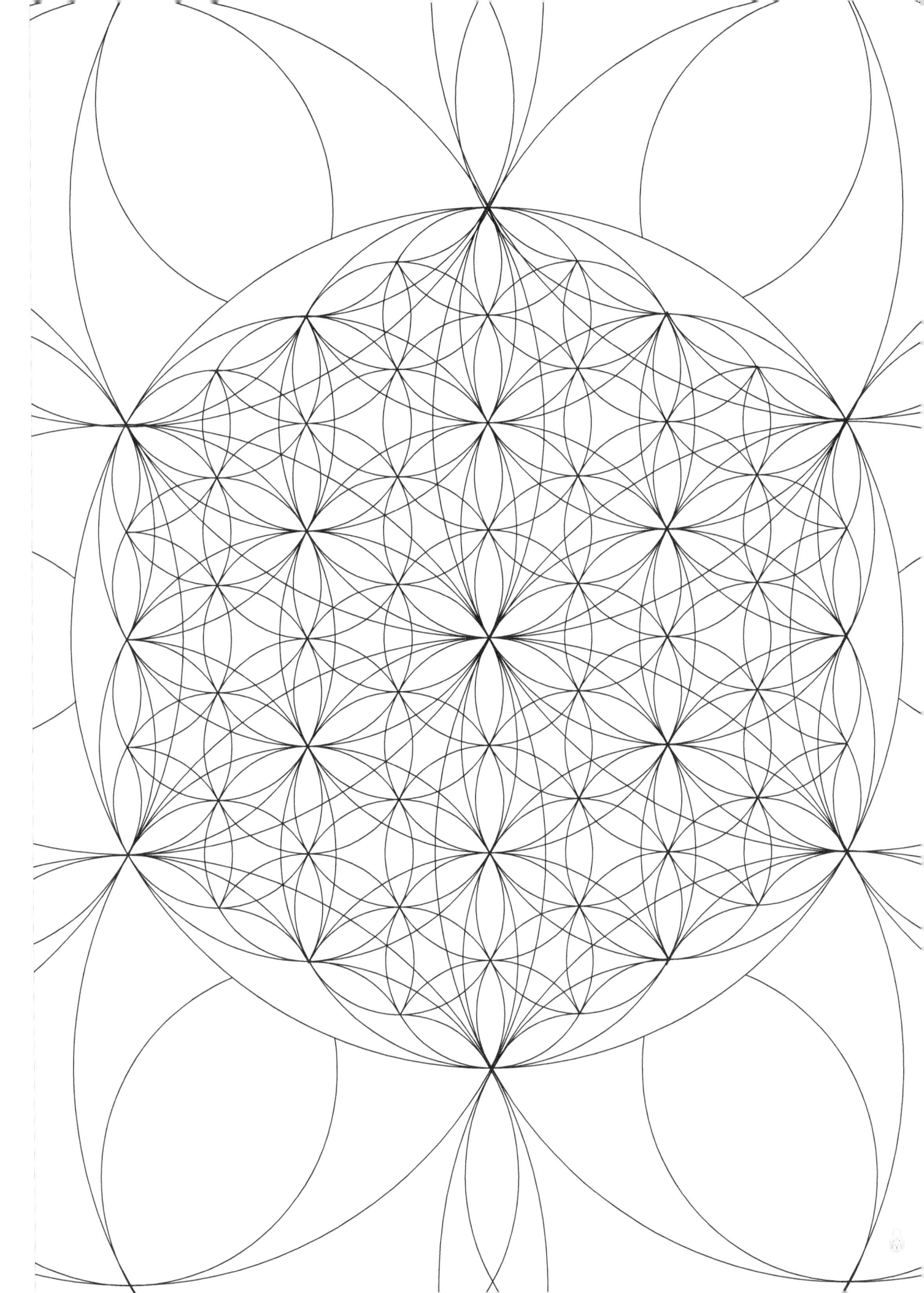

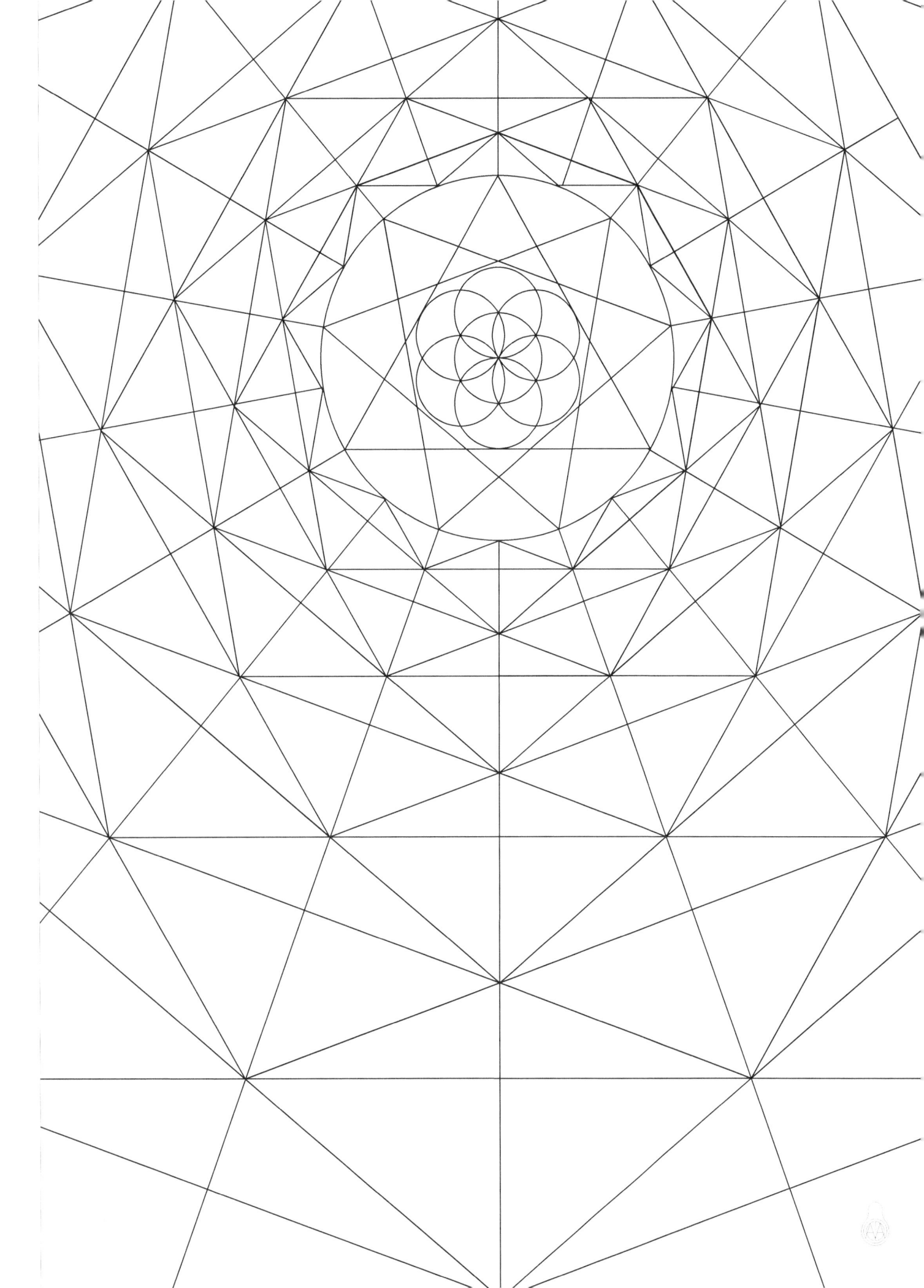

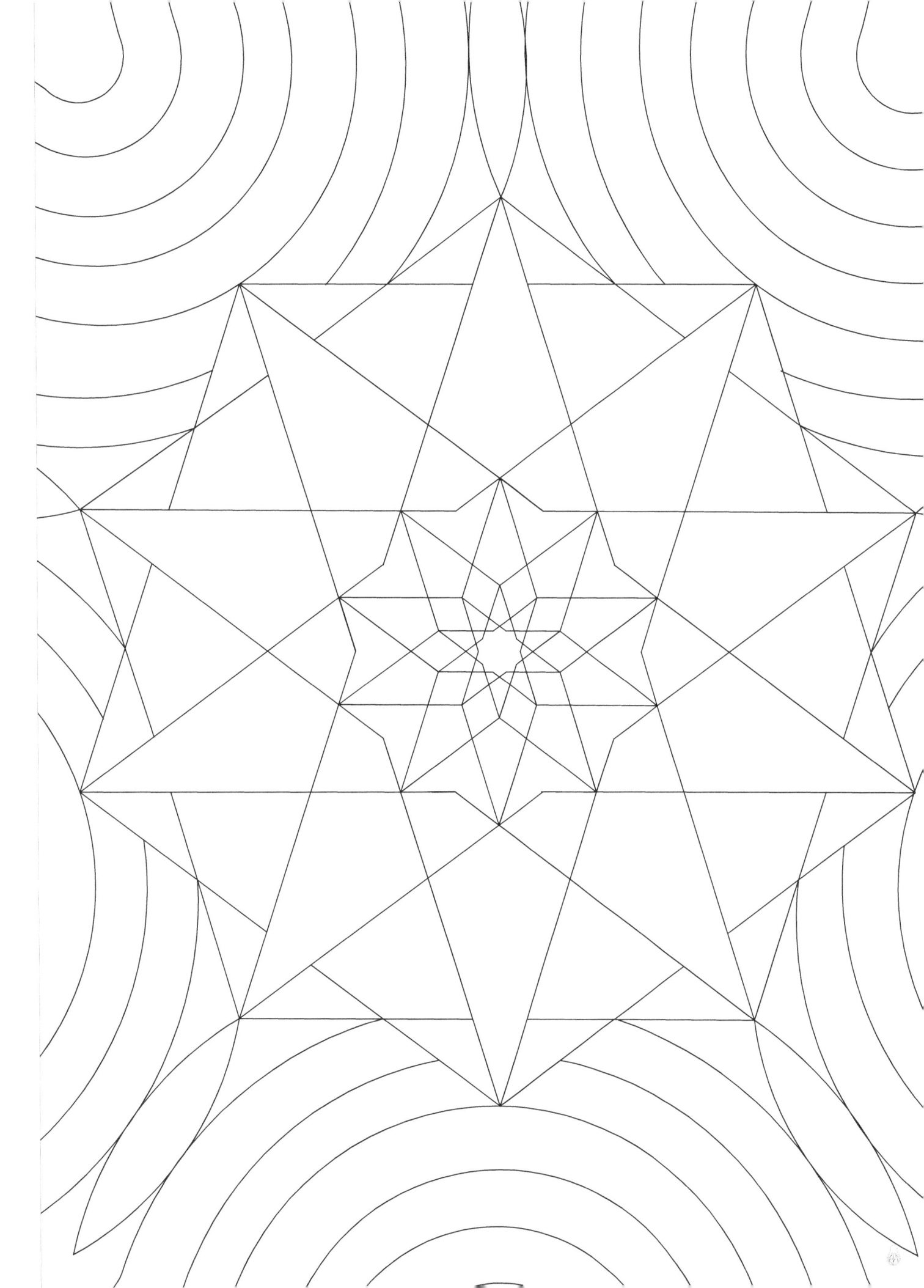

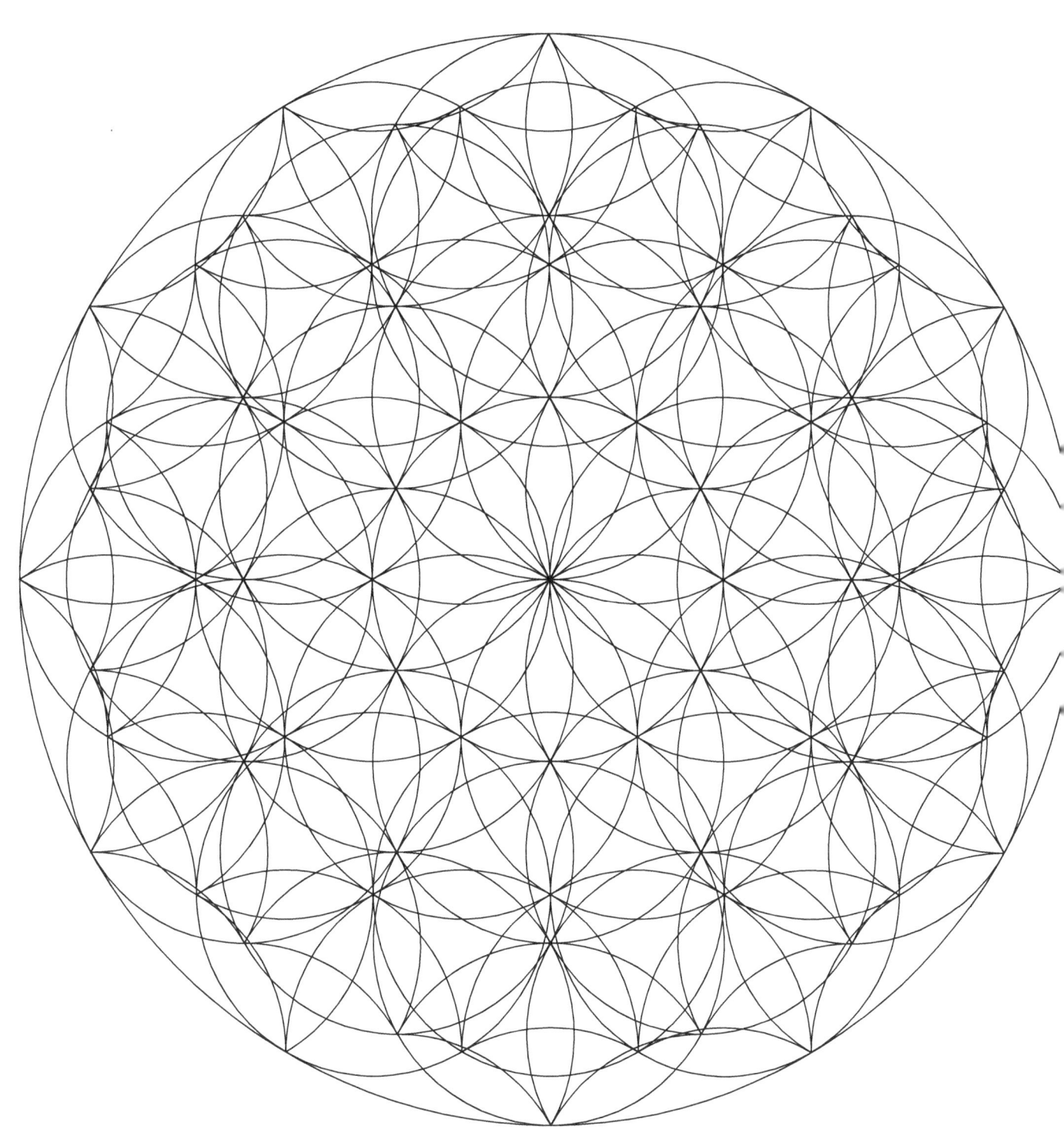

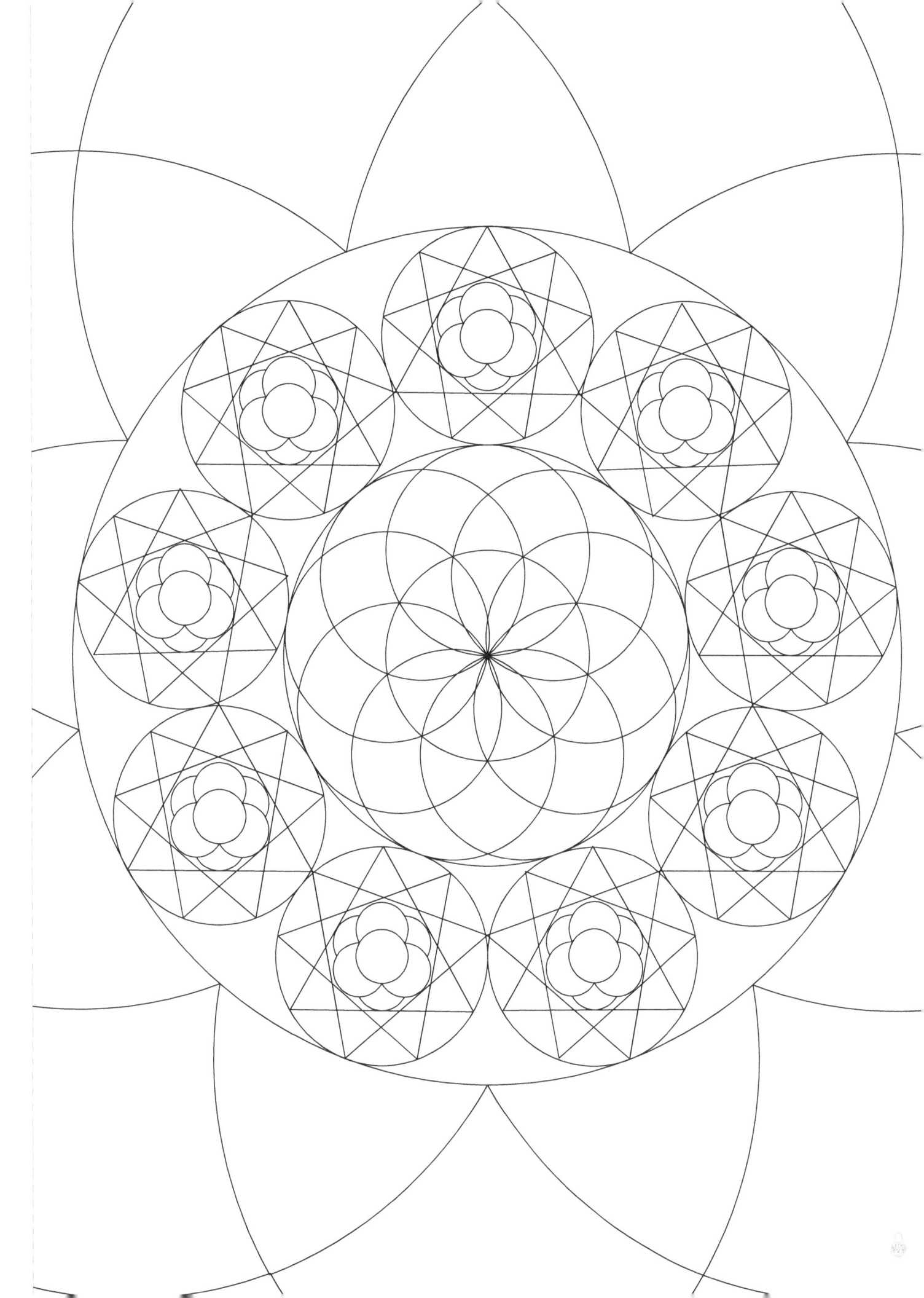

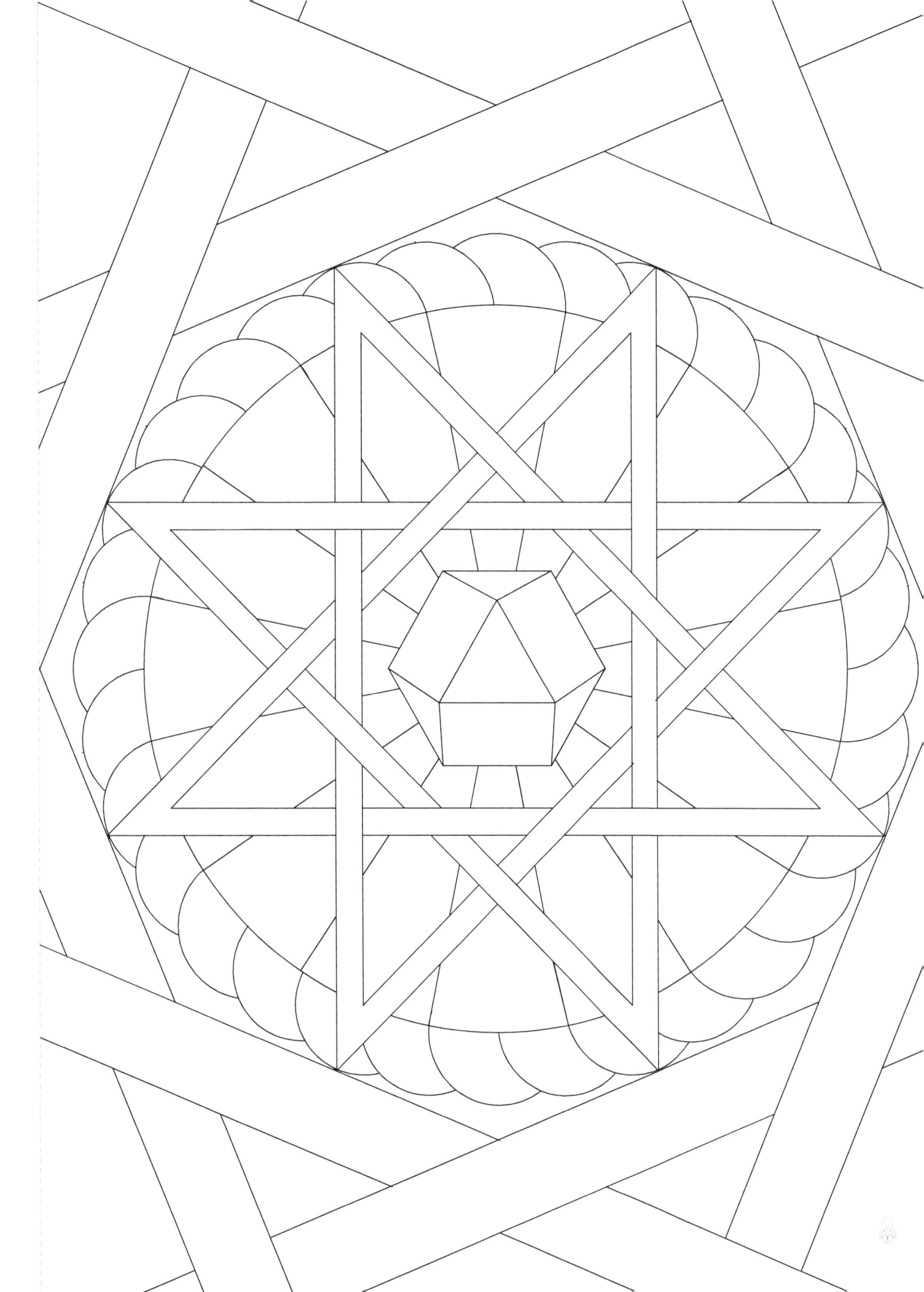

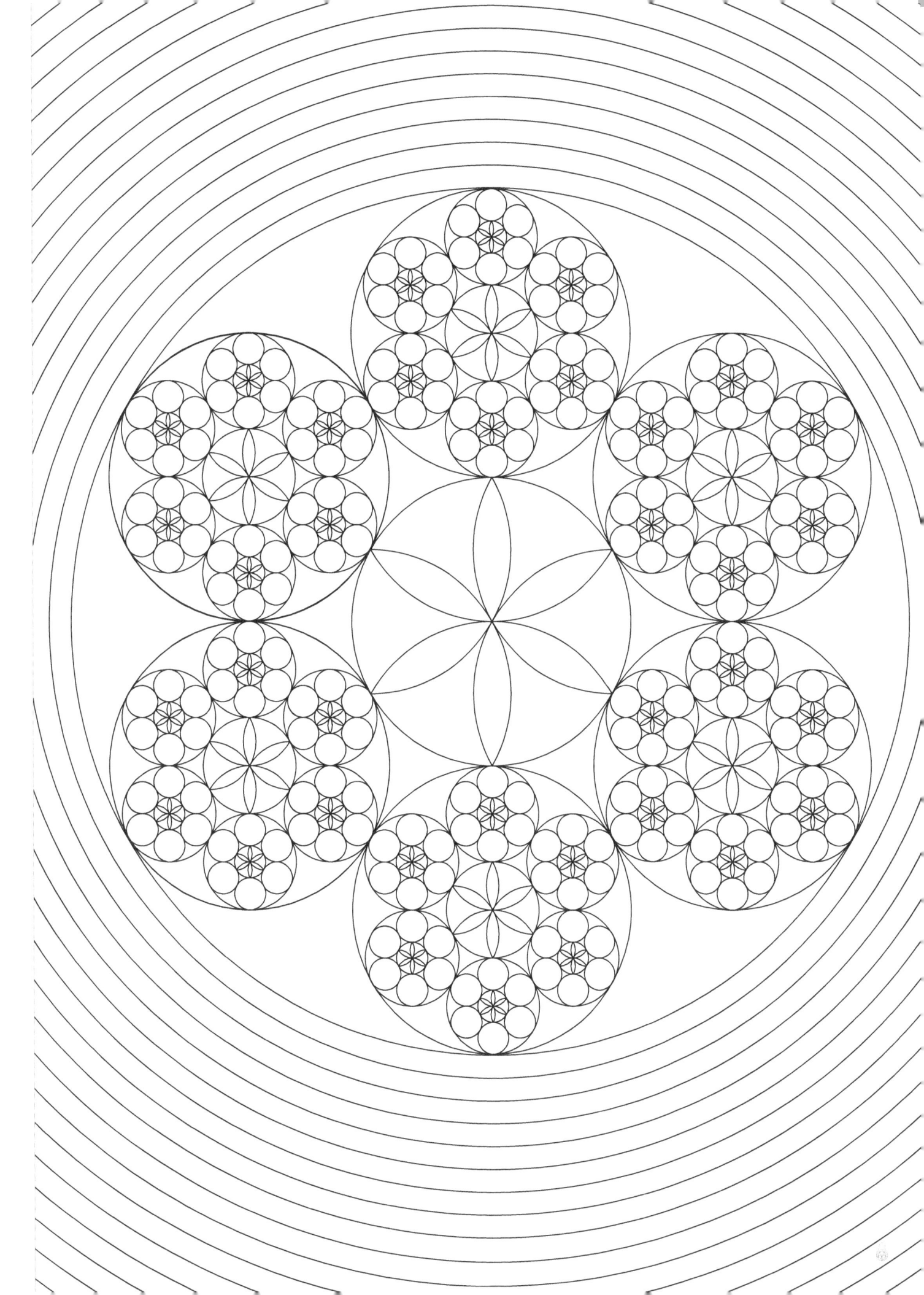

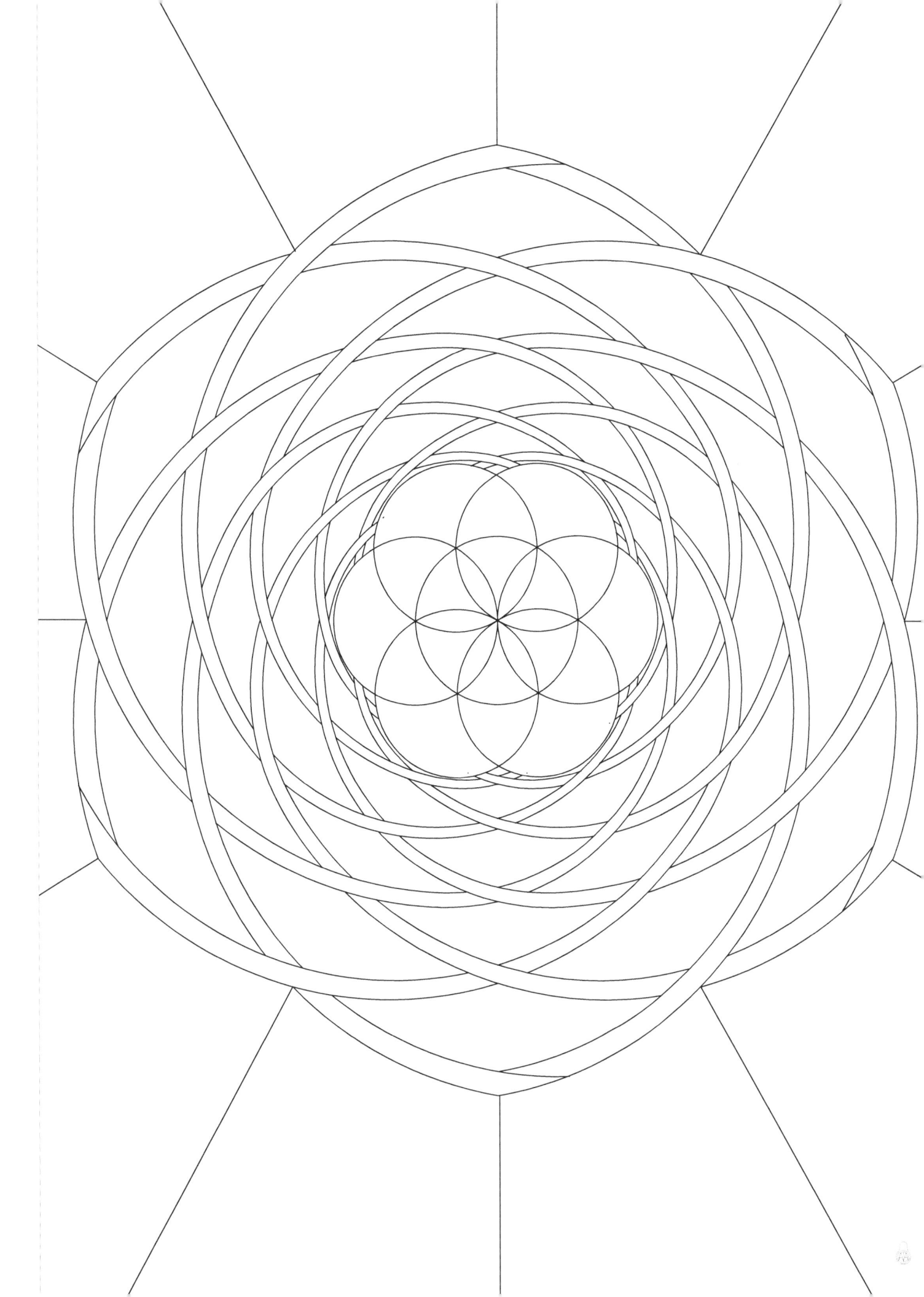

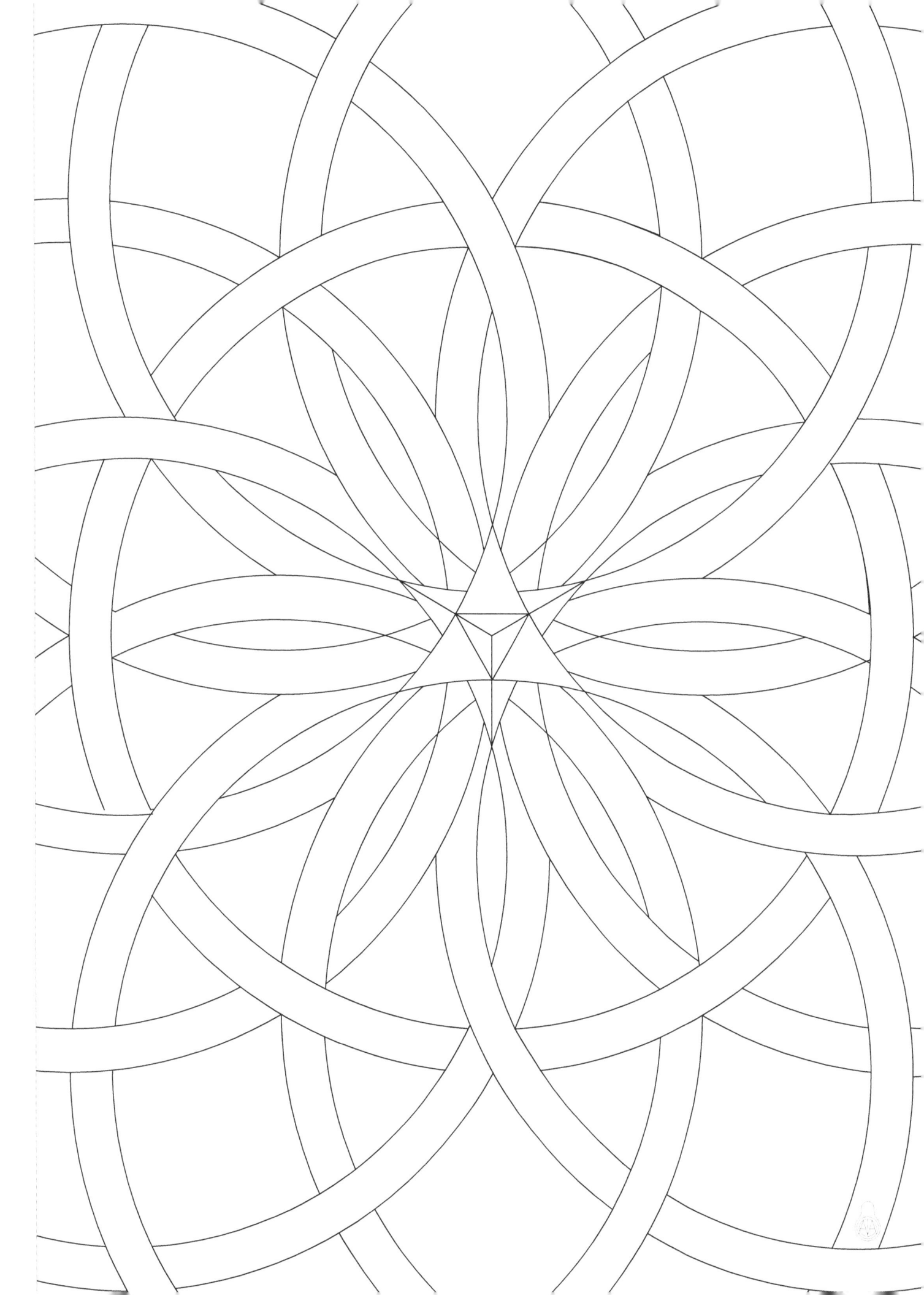

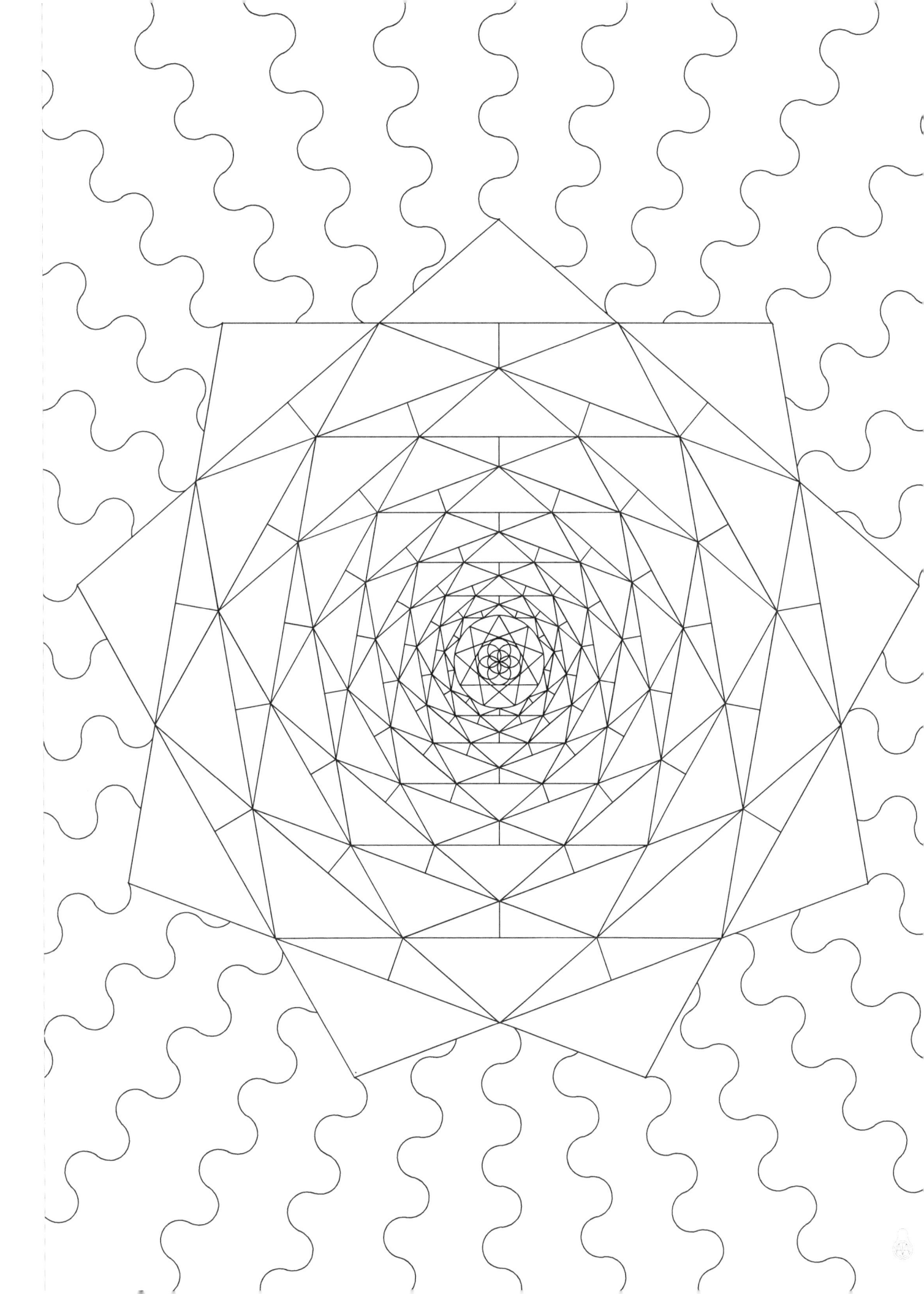

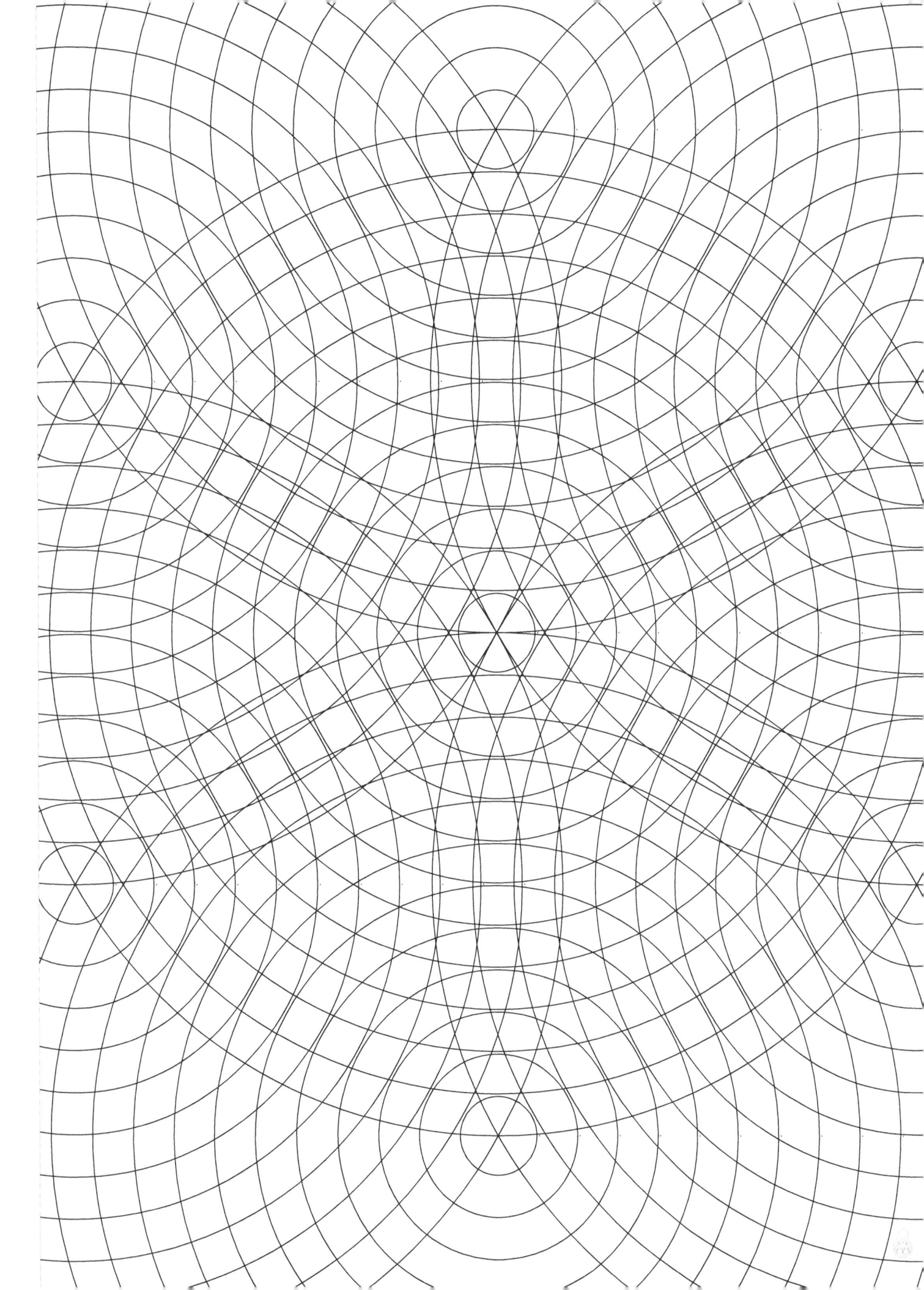

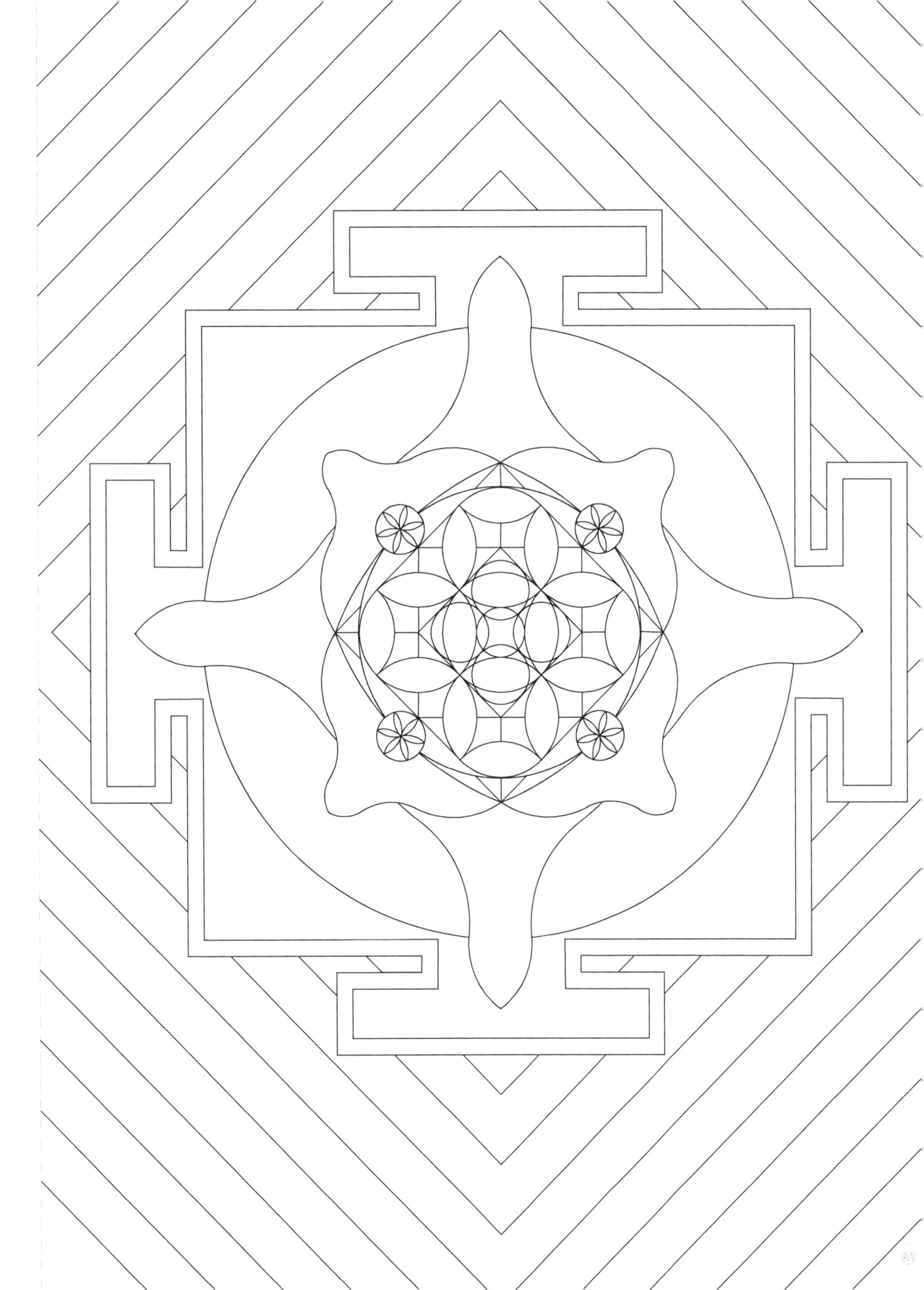

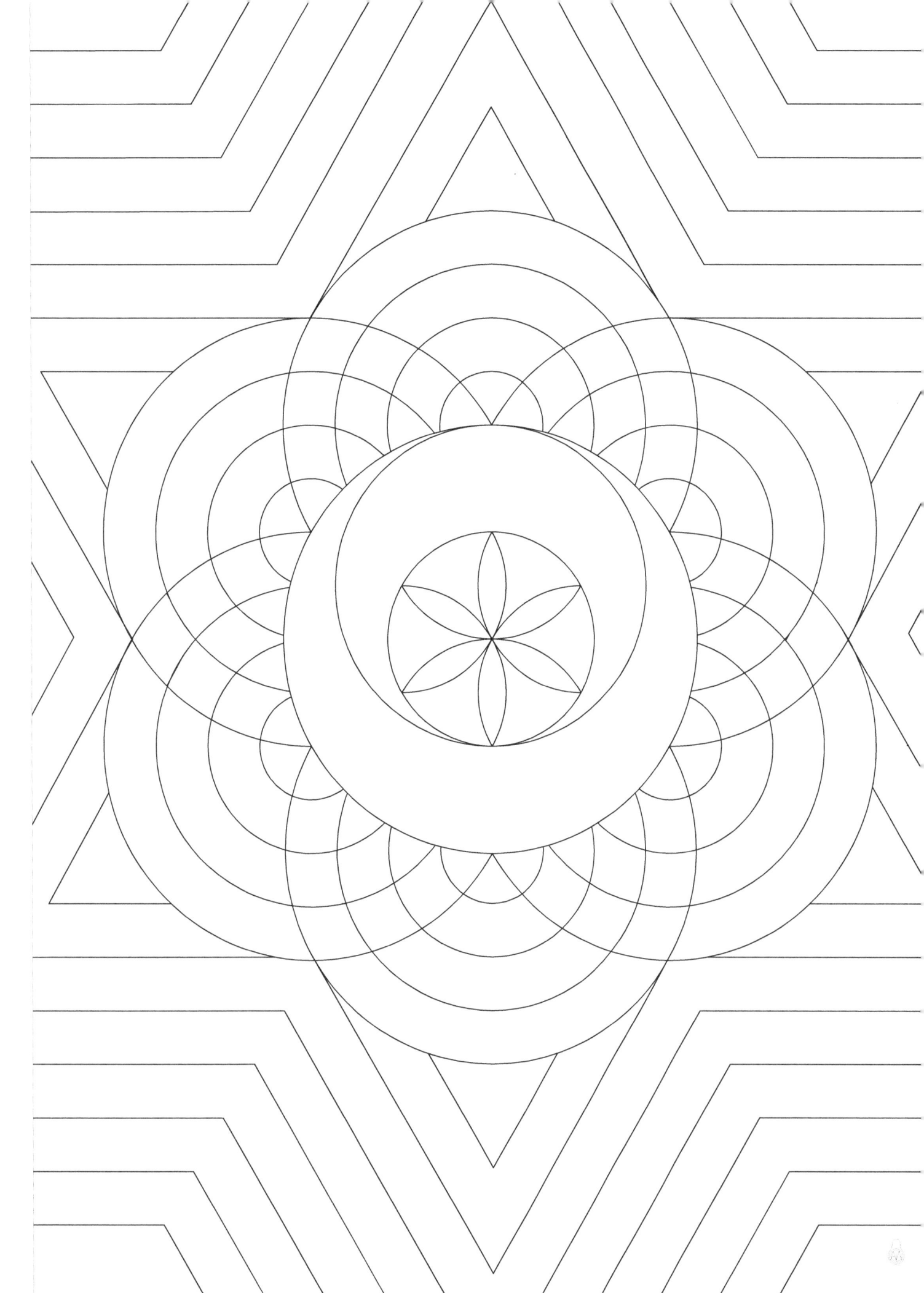

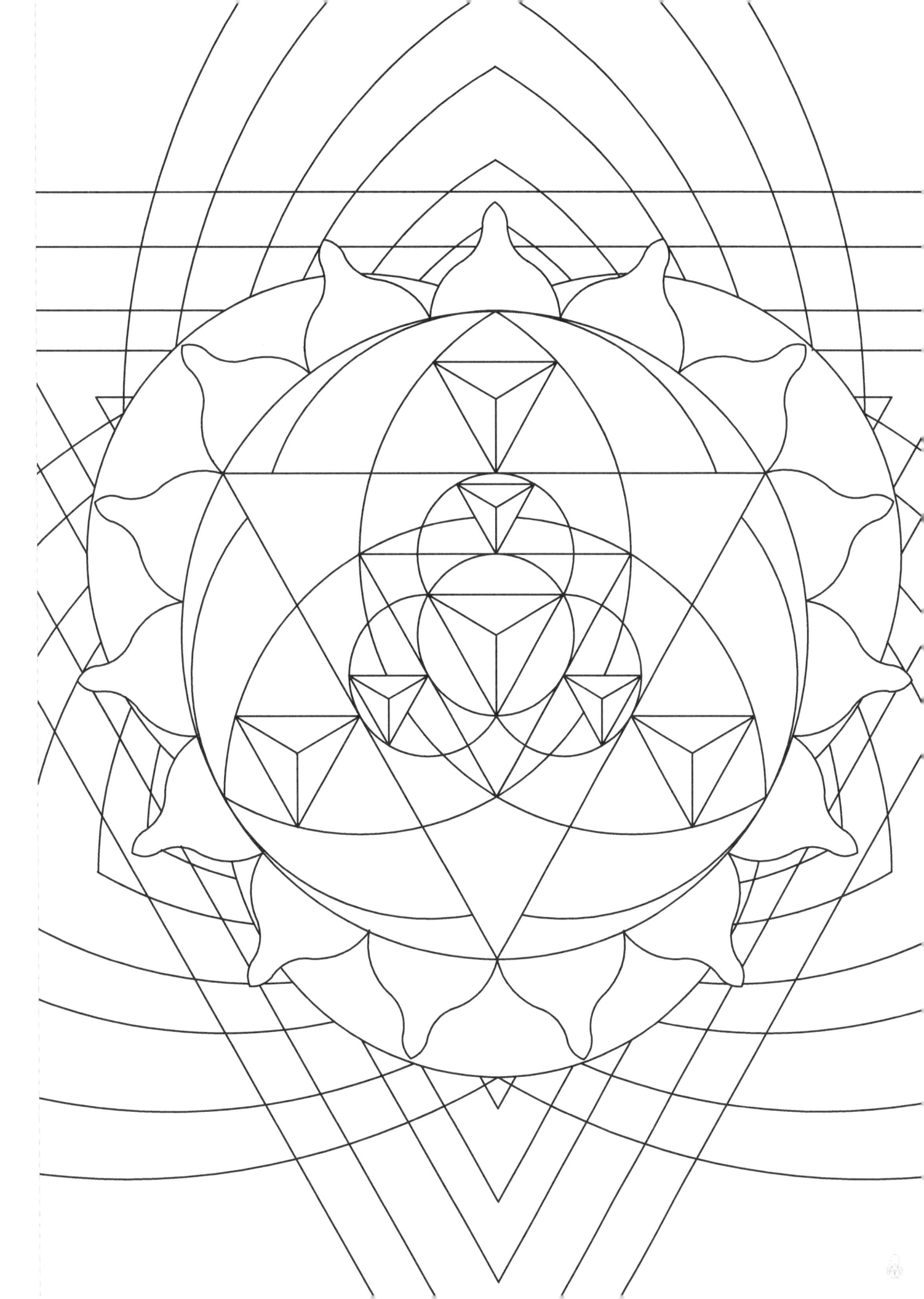

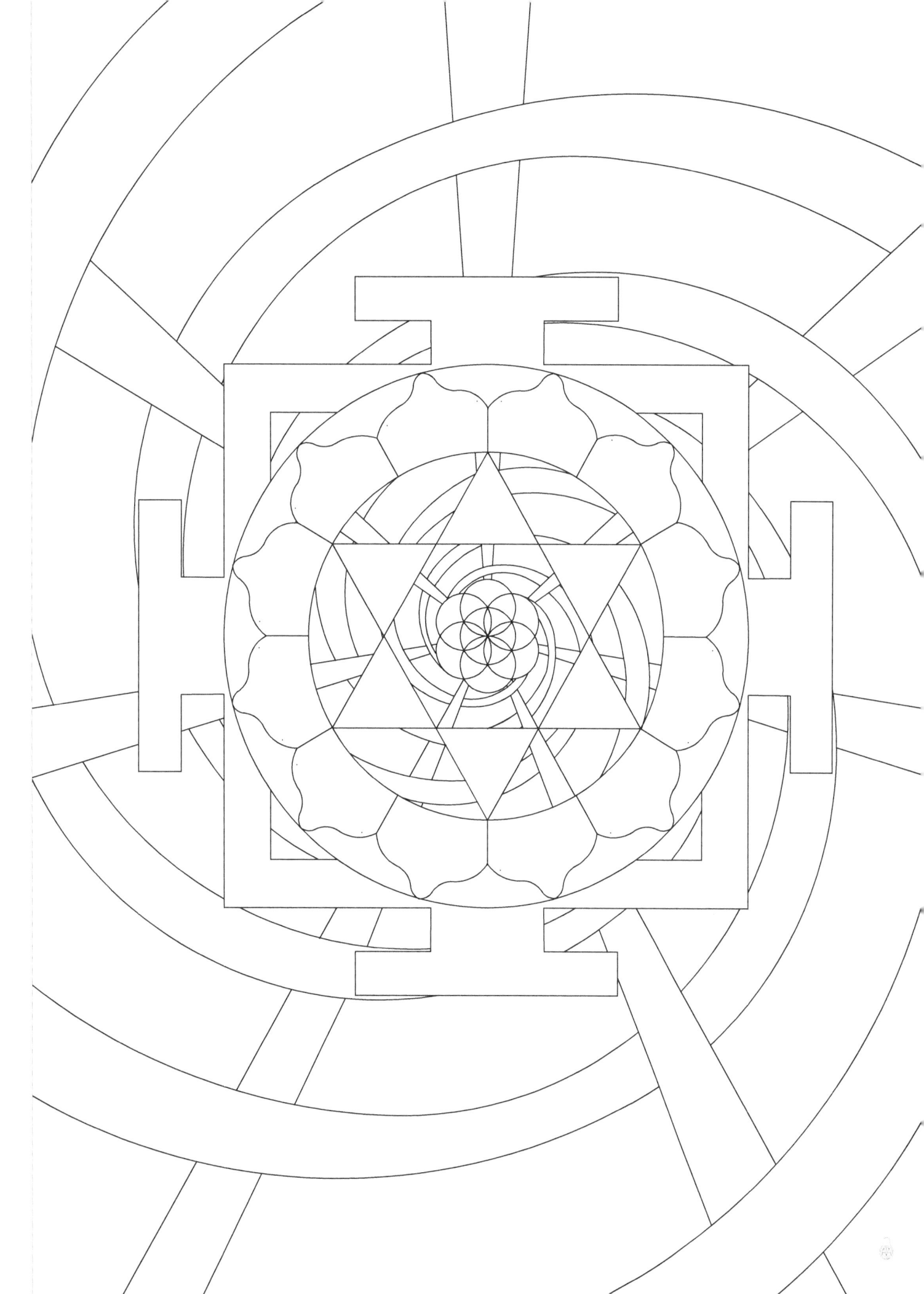

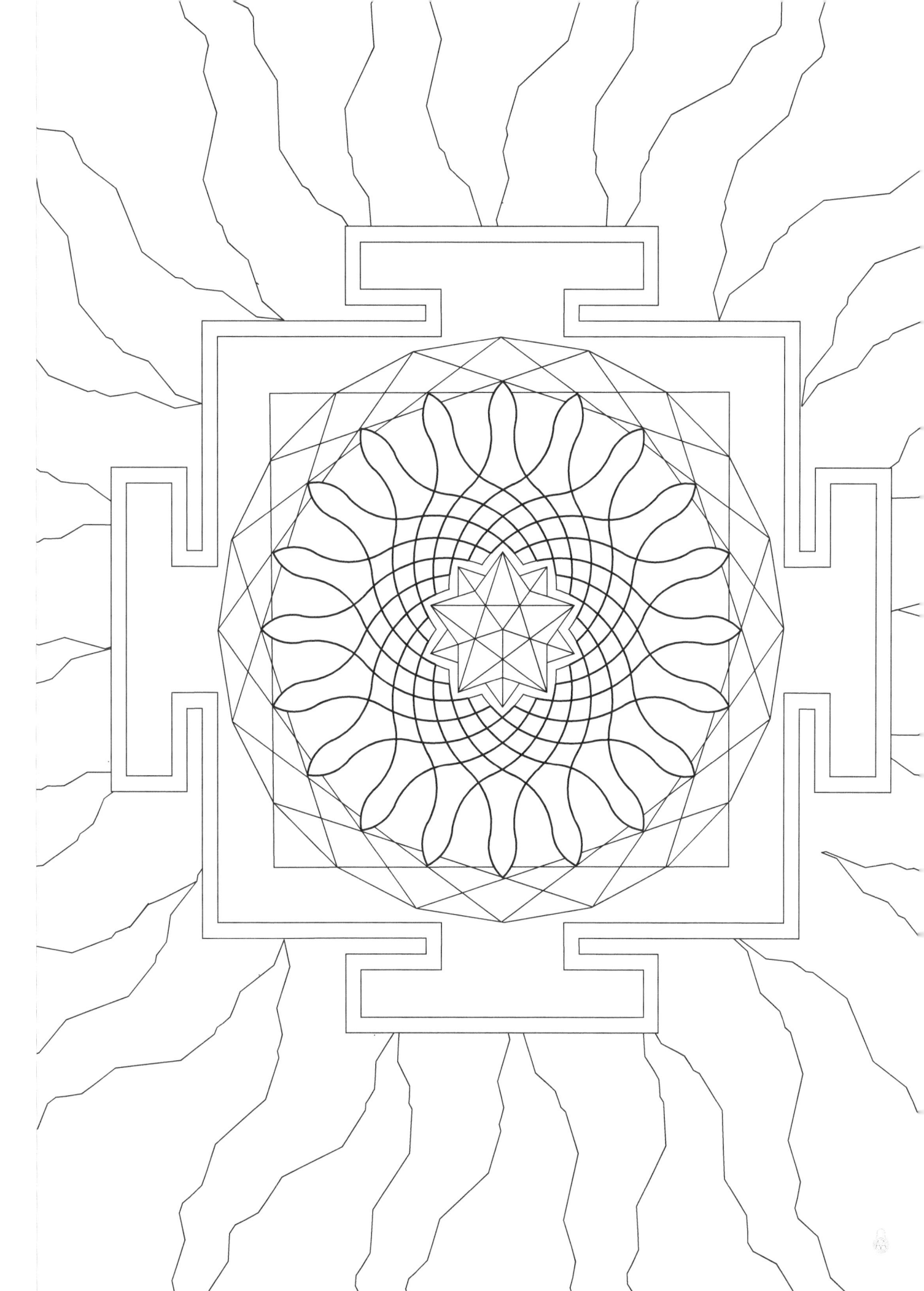

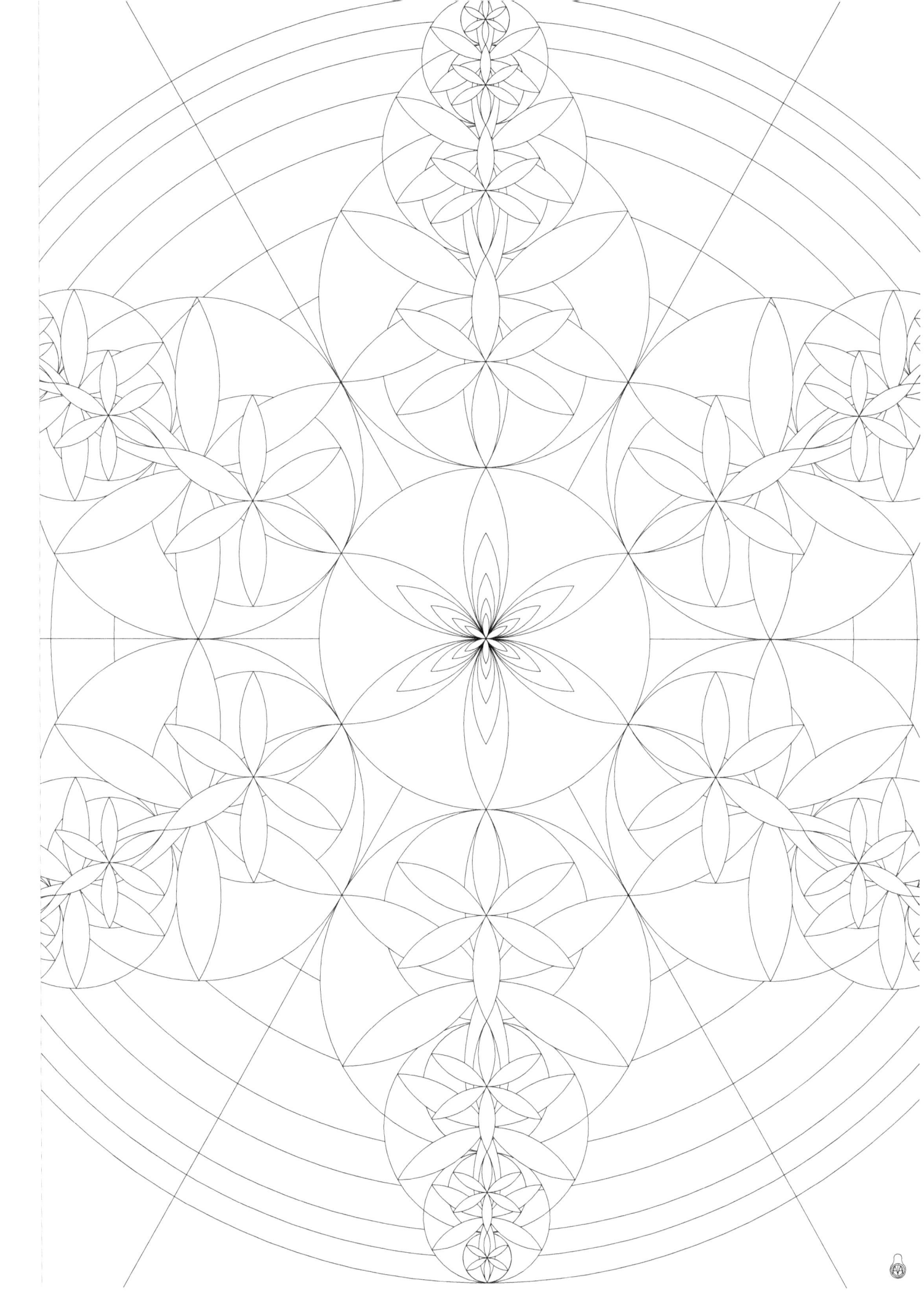

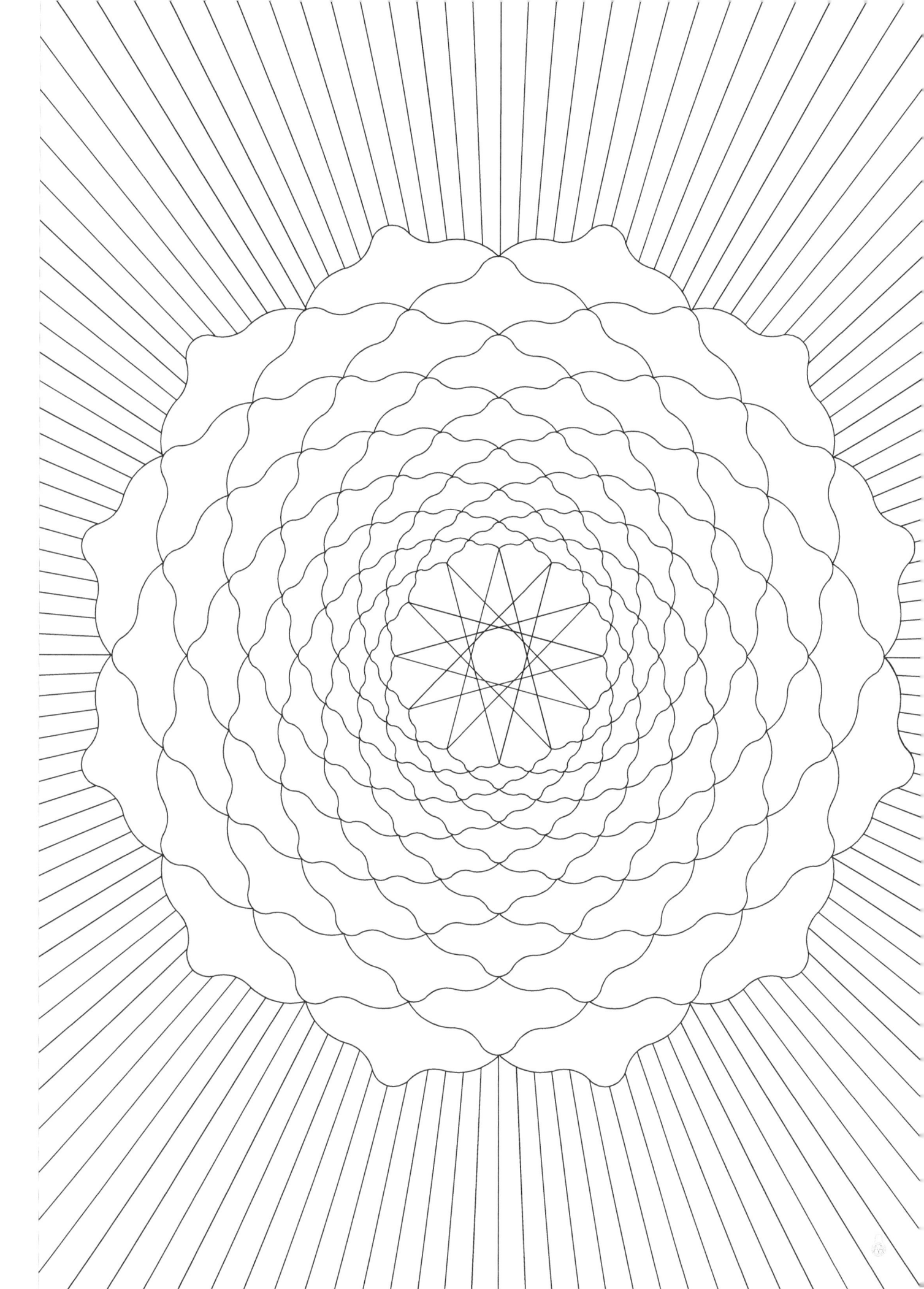

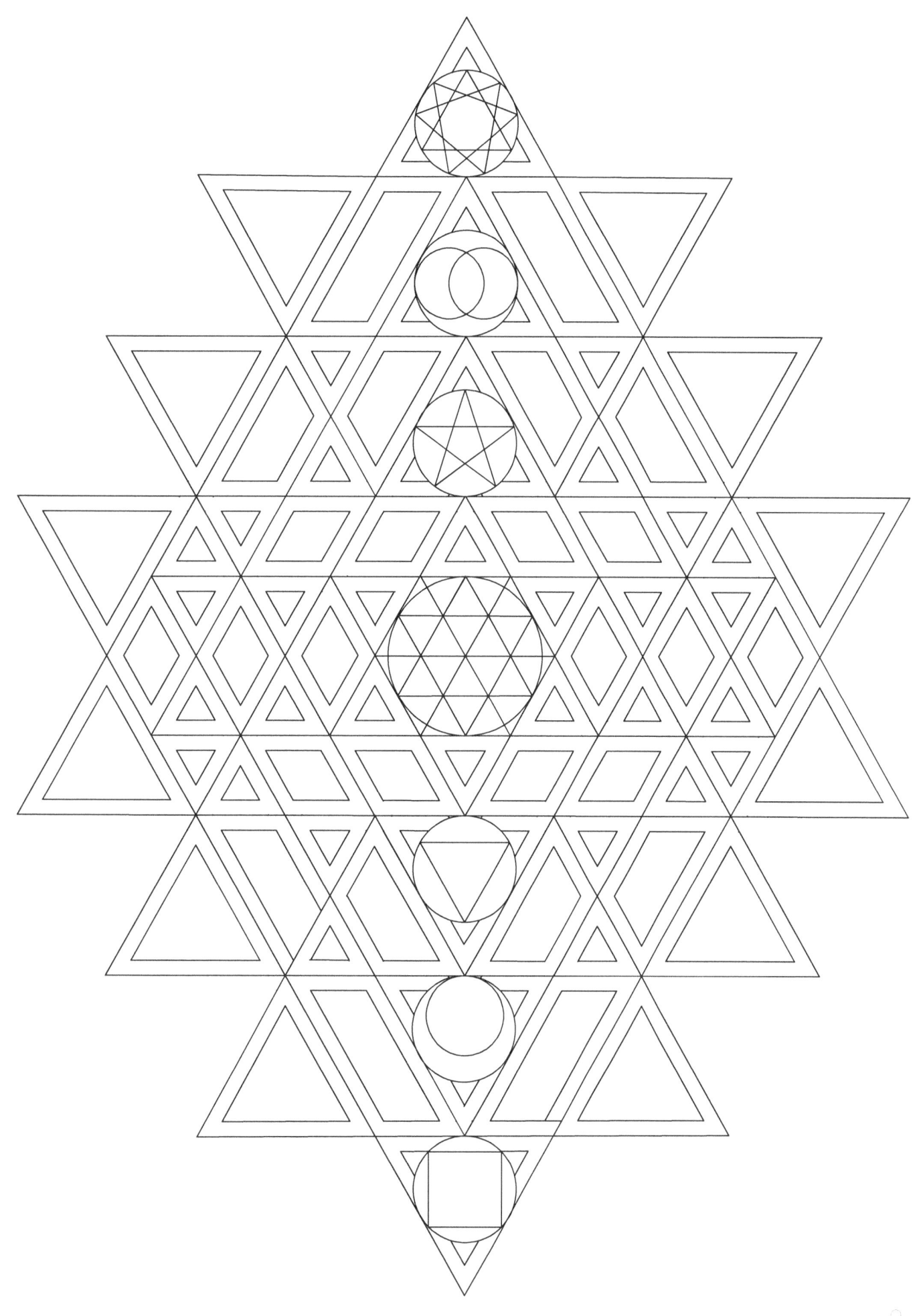

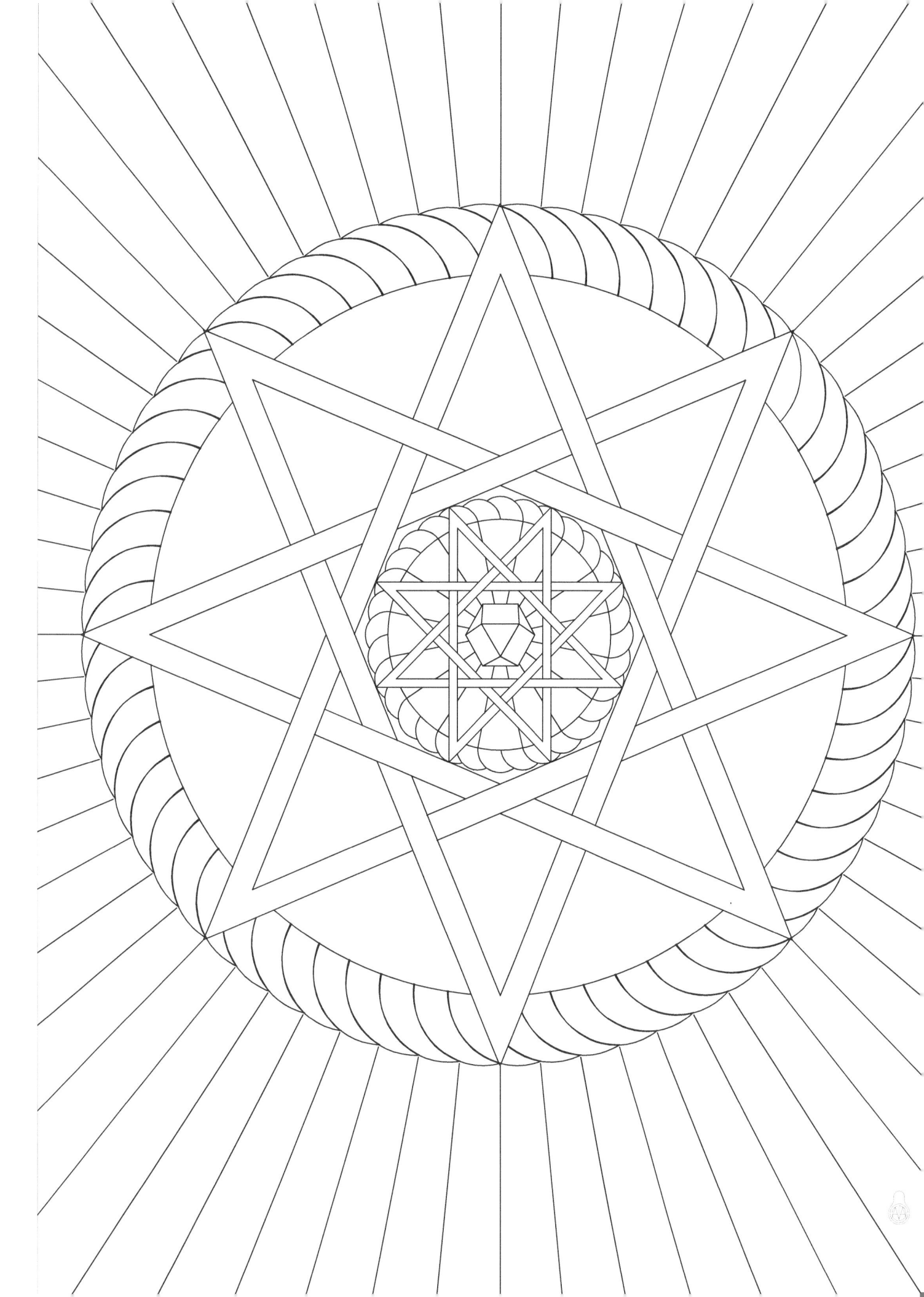

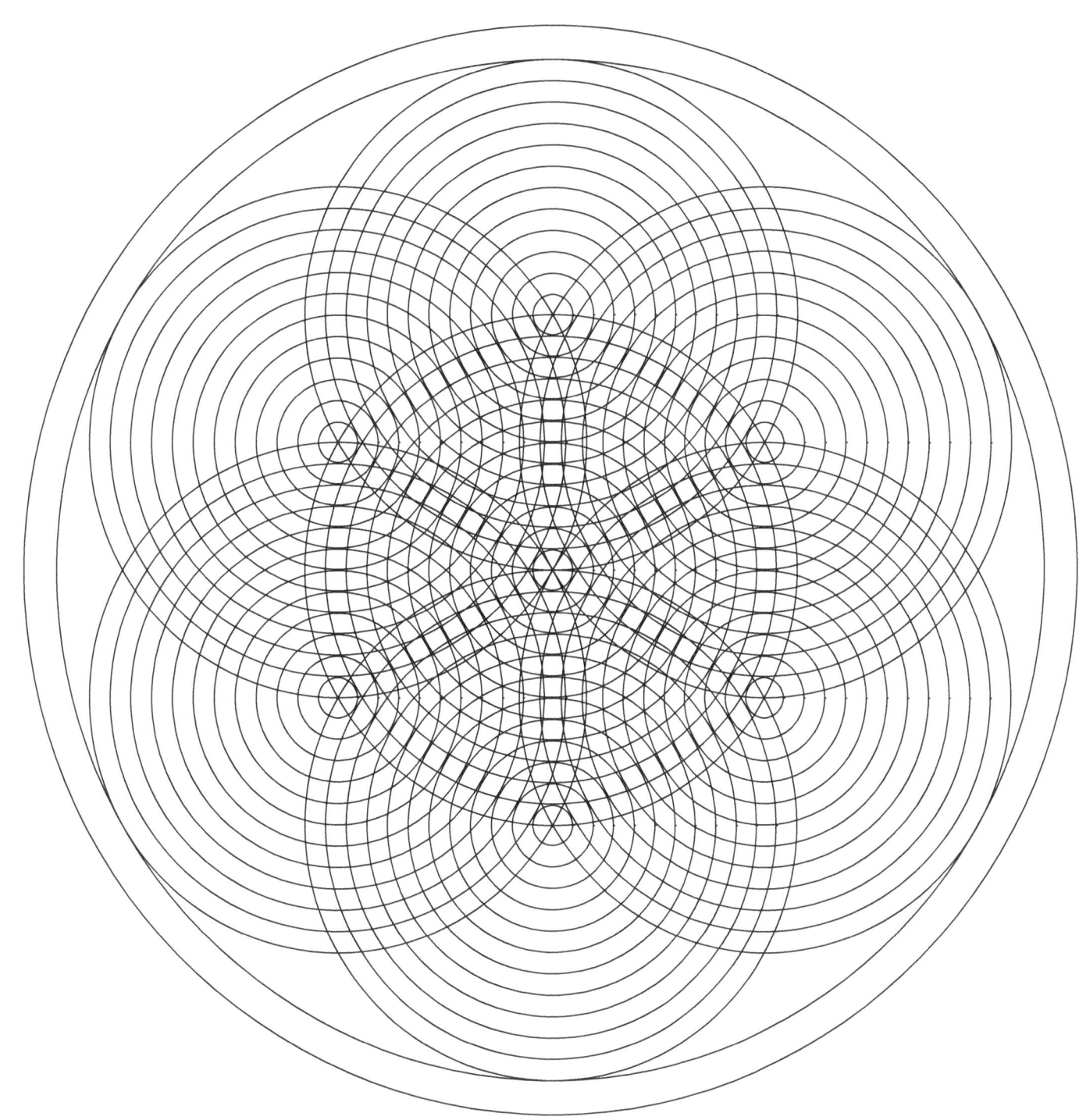

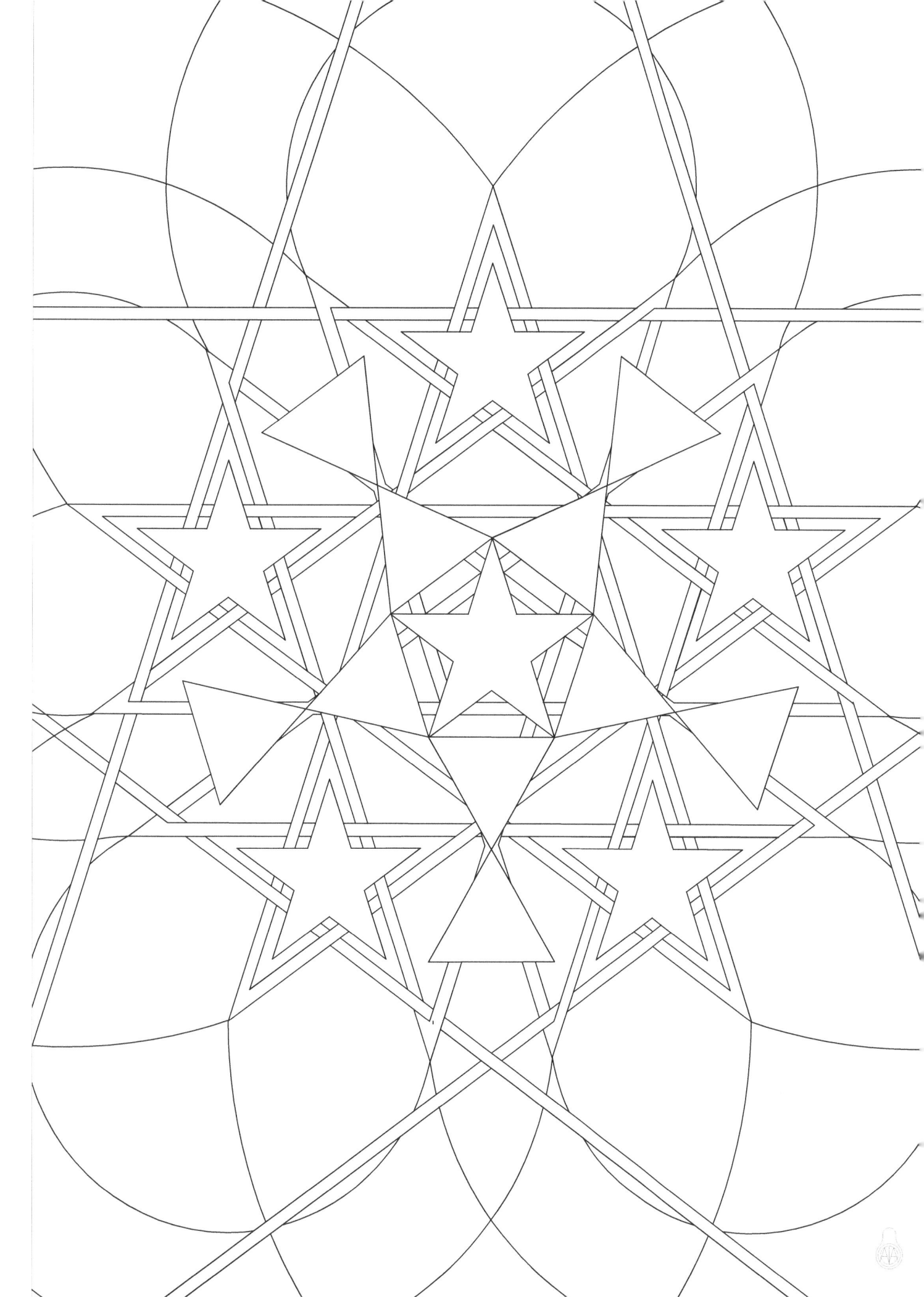

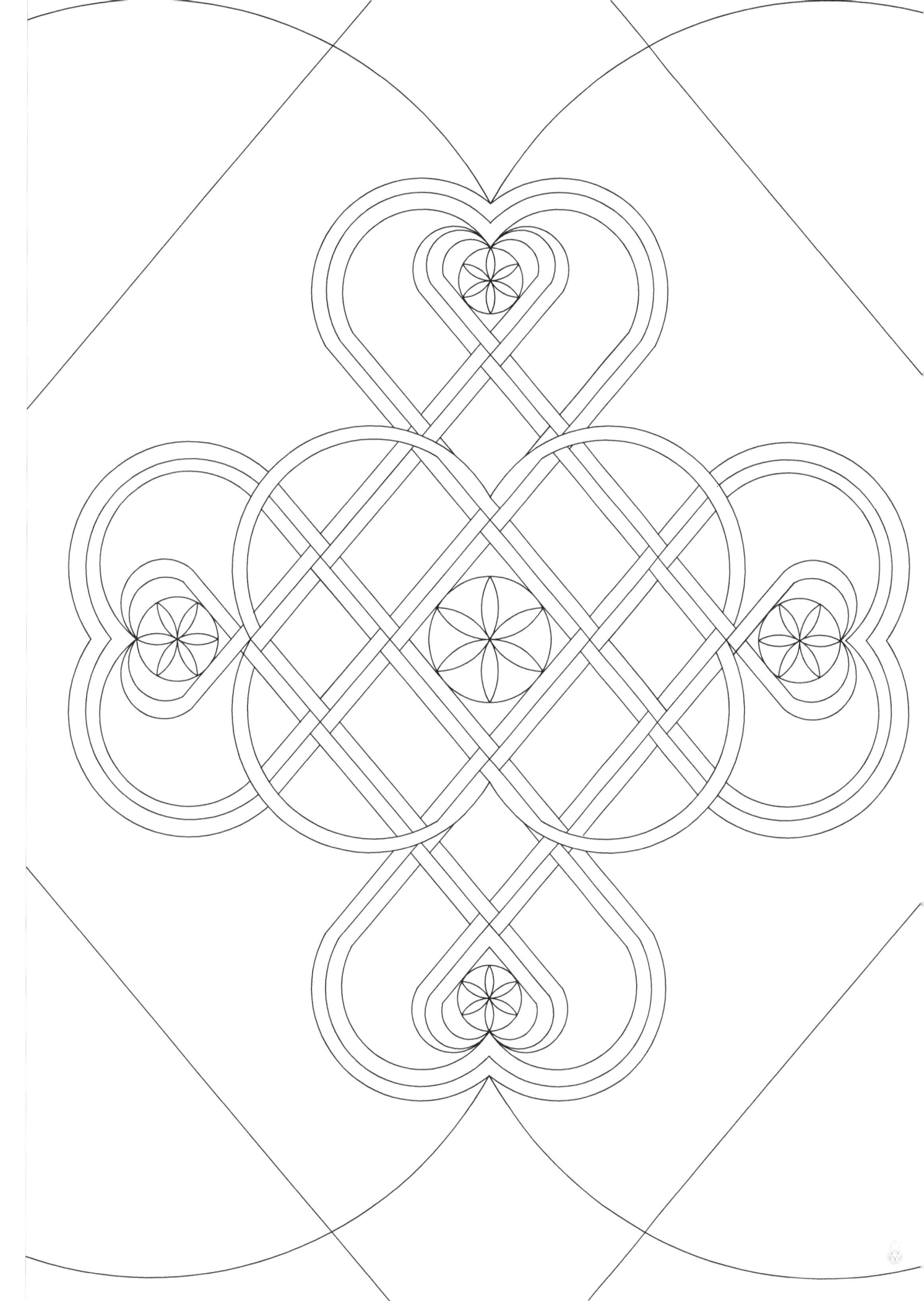

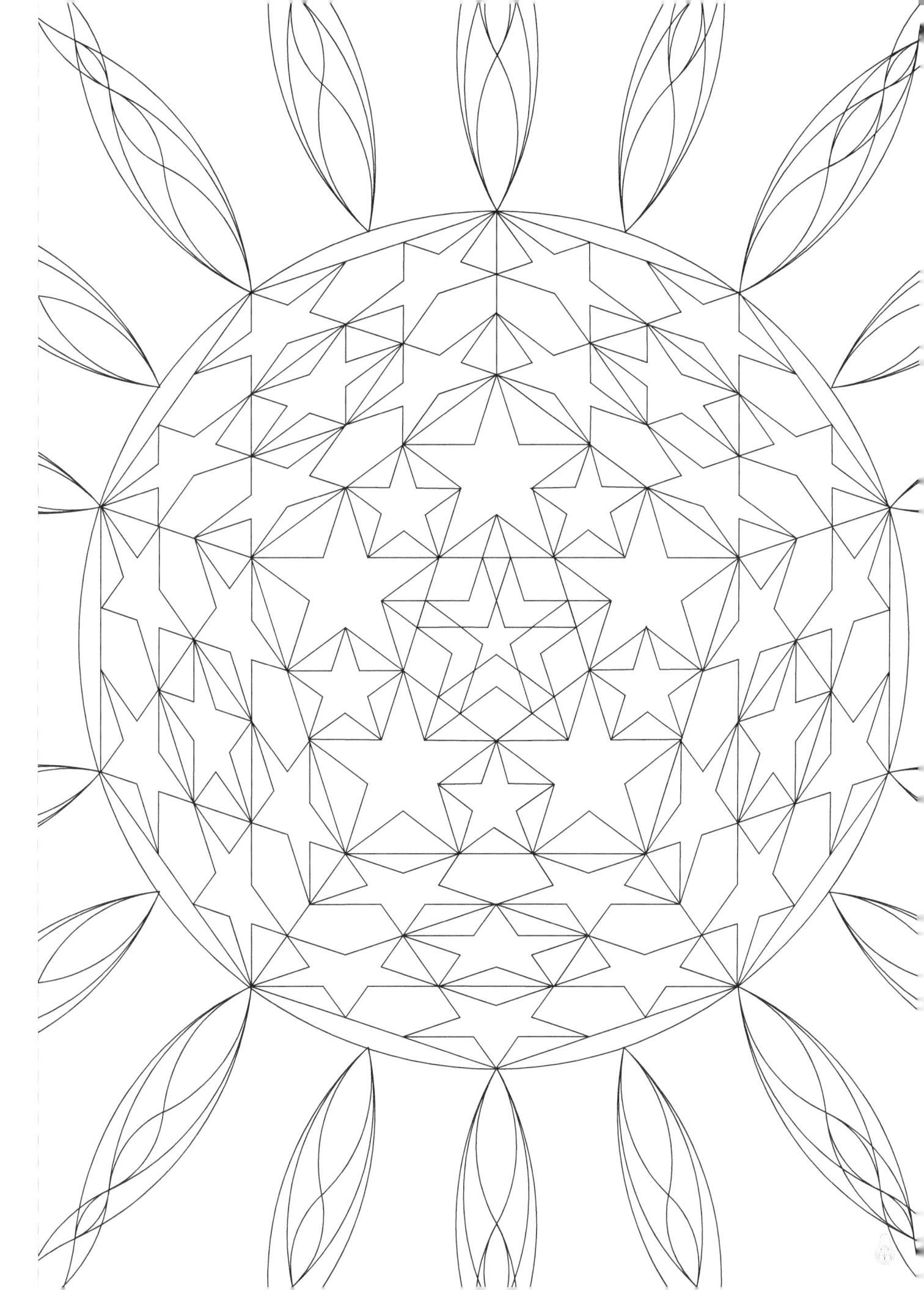

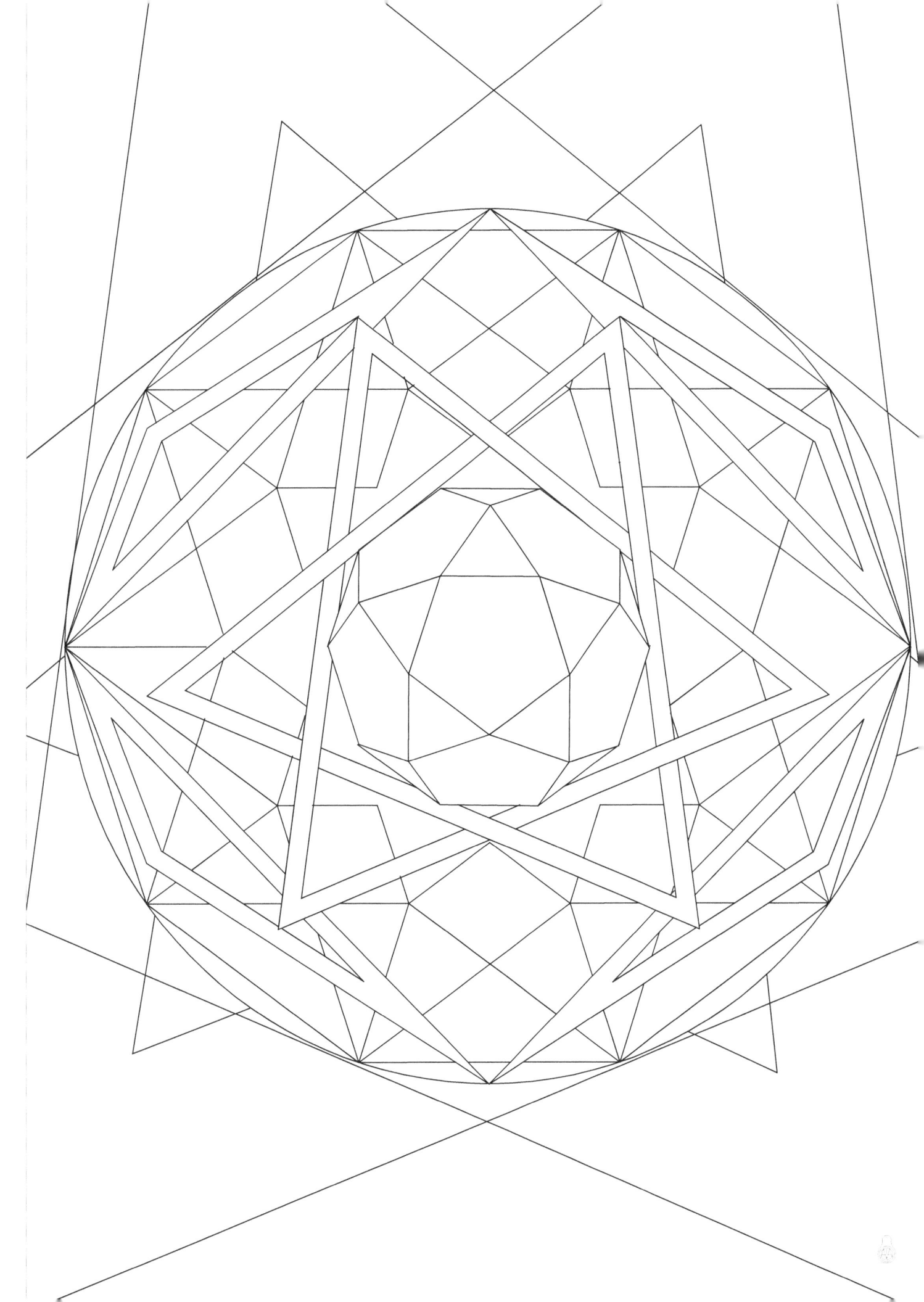

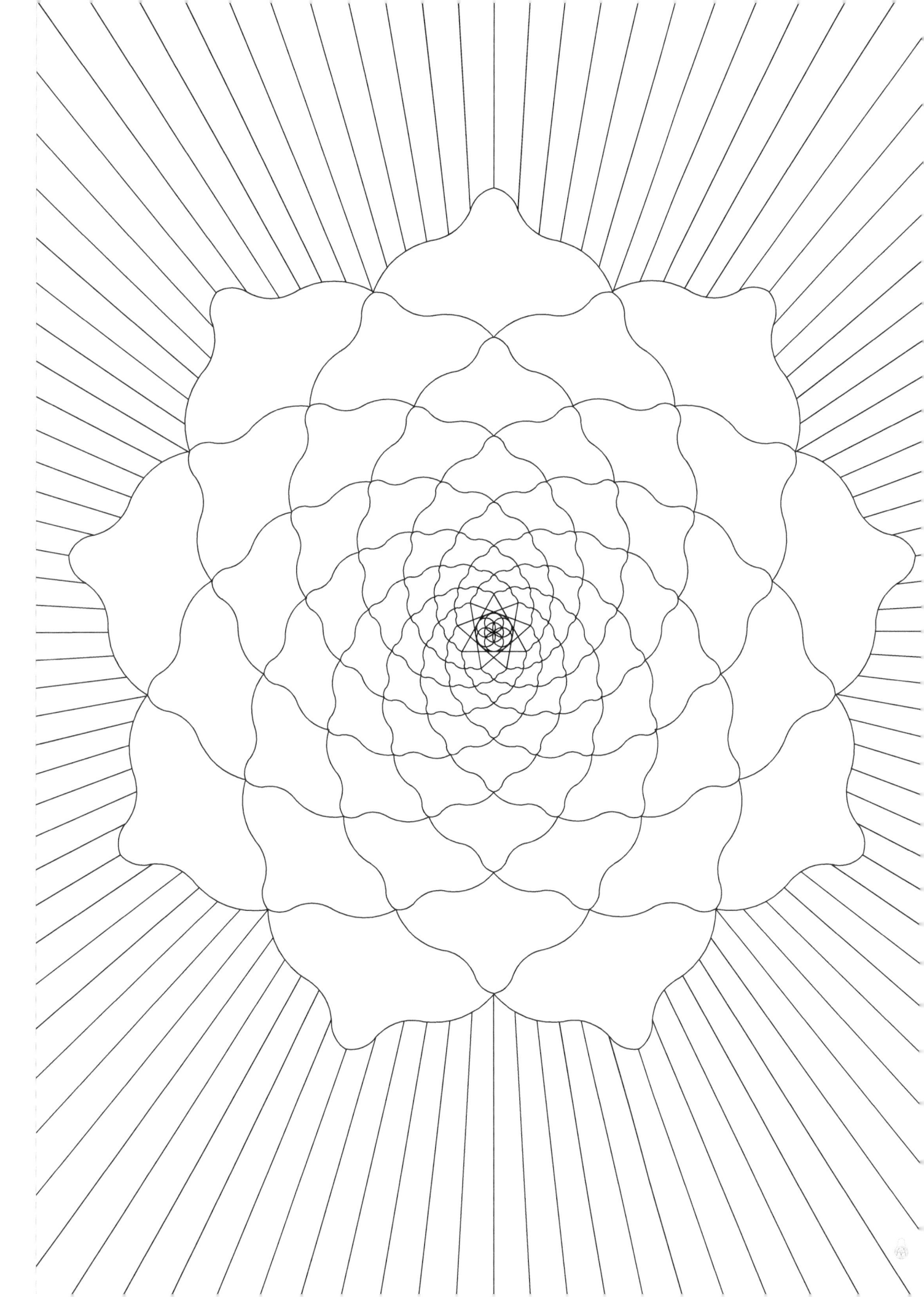

FOLD-UP STAR TETRAHEDRON

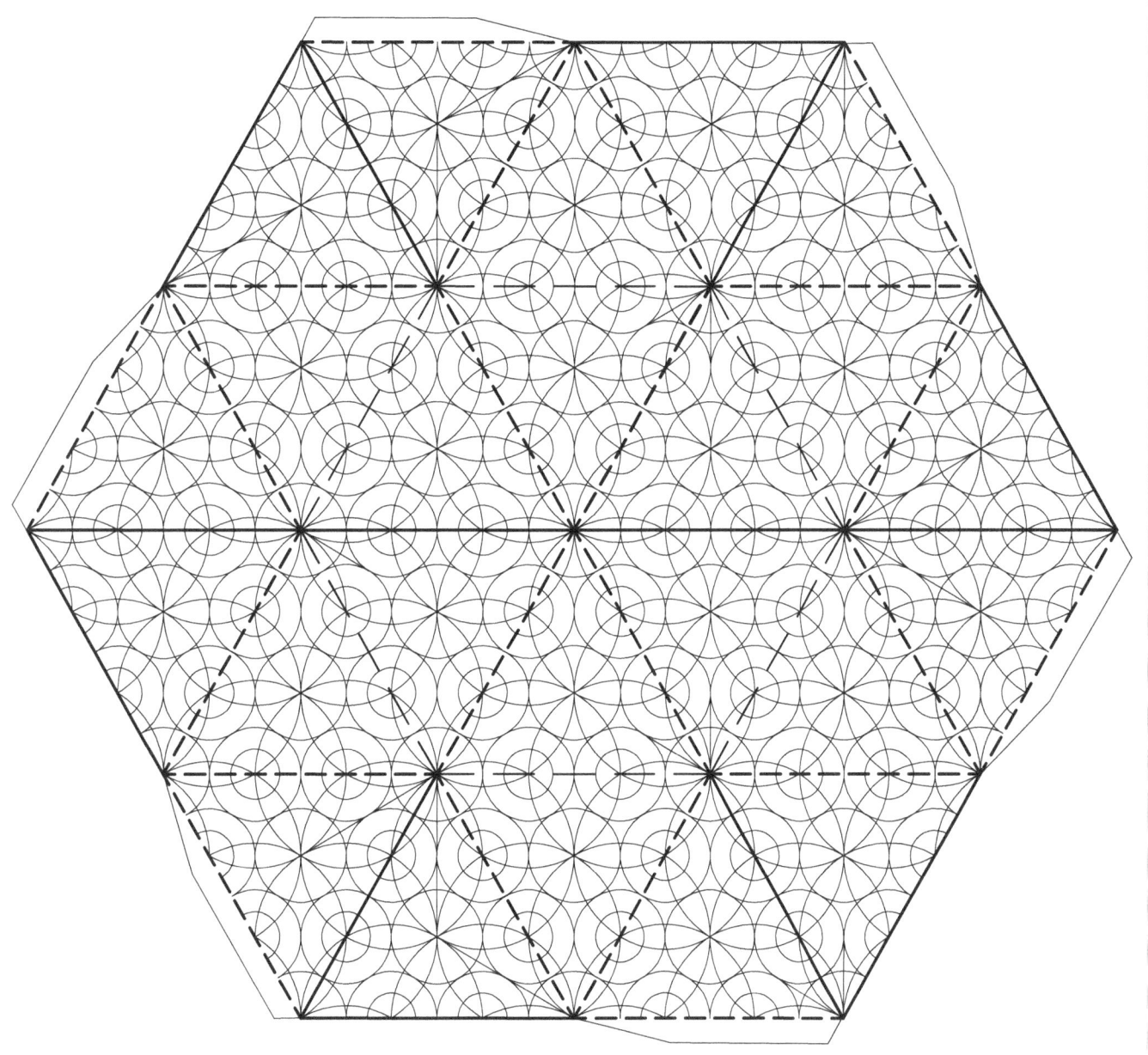

Legend

Fold　　– – – – –

Back Fold　– — — —

Cut　　———

Instructions:
1. Cut colored design in half along bold line.
2. Cut bold lines.
3. Back fold by bringing the colored sides to touch along un-bold dashed lines.
4. Unfold back folds, then fold along smaller, bold dashed lines.
5. Glue tabs together to make tetrahedrons.
6. Use tape to hold central tetrahedron together.
7. Tape both halves together. Tape will be outside on final junctions.

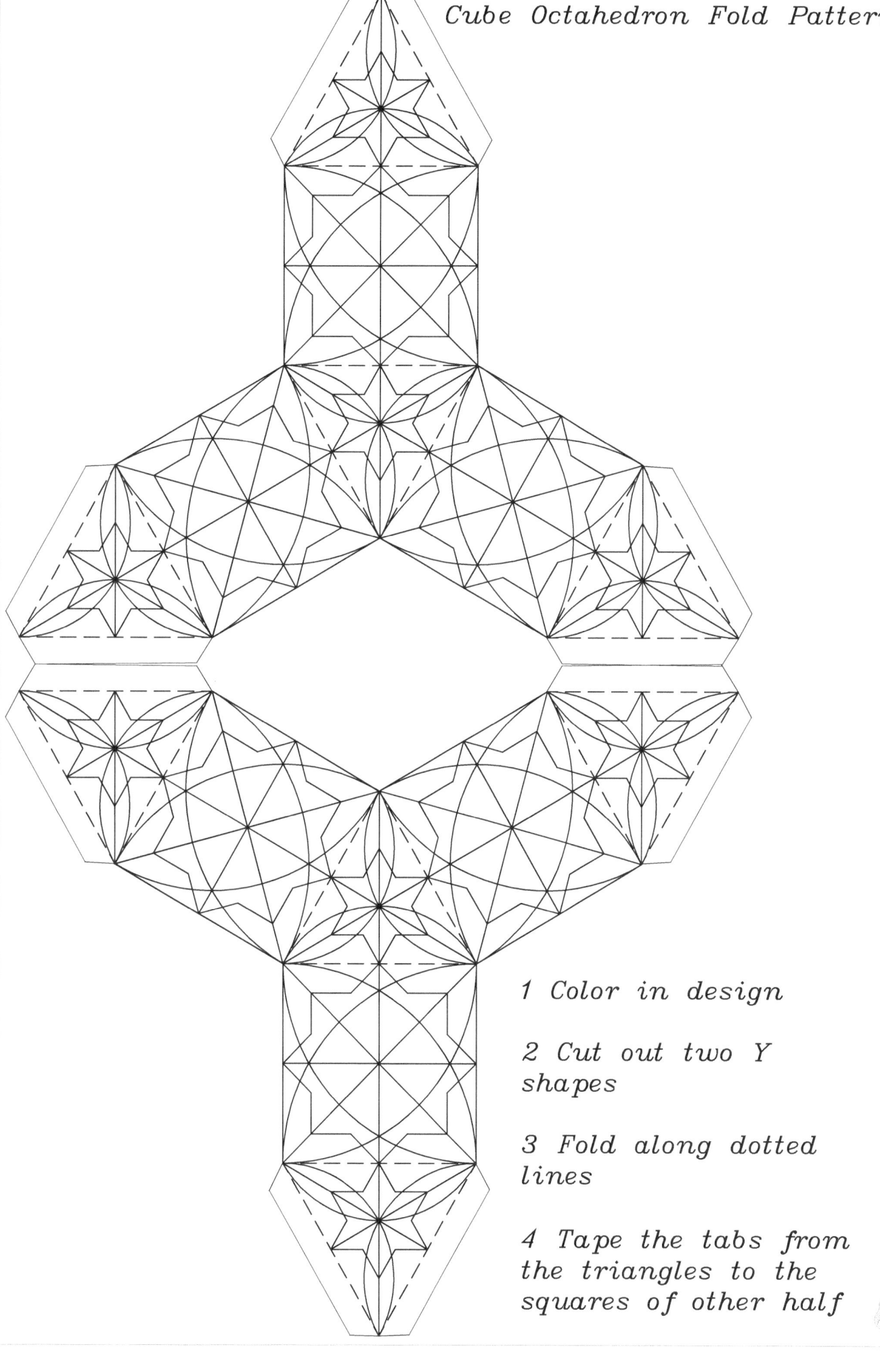

Cube Octahedron Fold Pattern

1 Color in design

2 Cut out two Y shapes

3 Fold along dotted lines

4 Tape the tabs from the triangles to the squares of other half

Icosiododecahedron Fold-Up Pattern

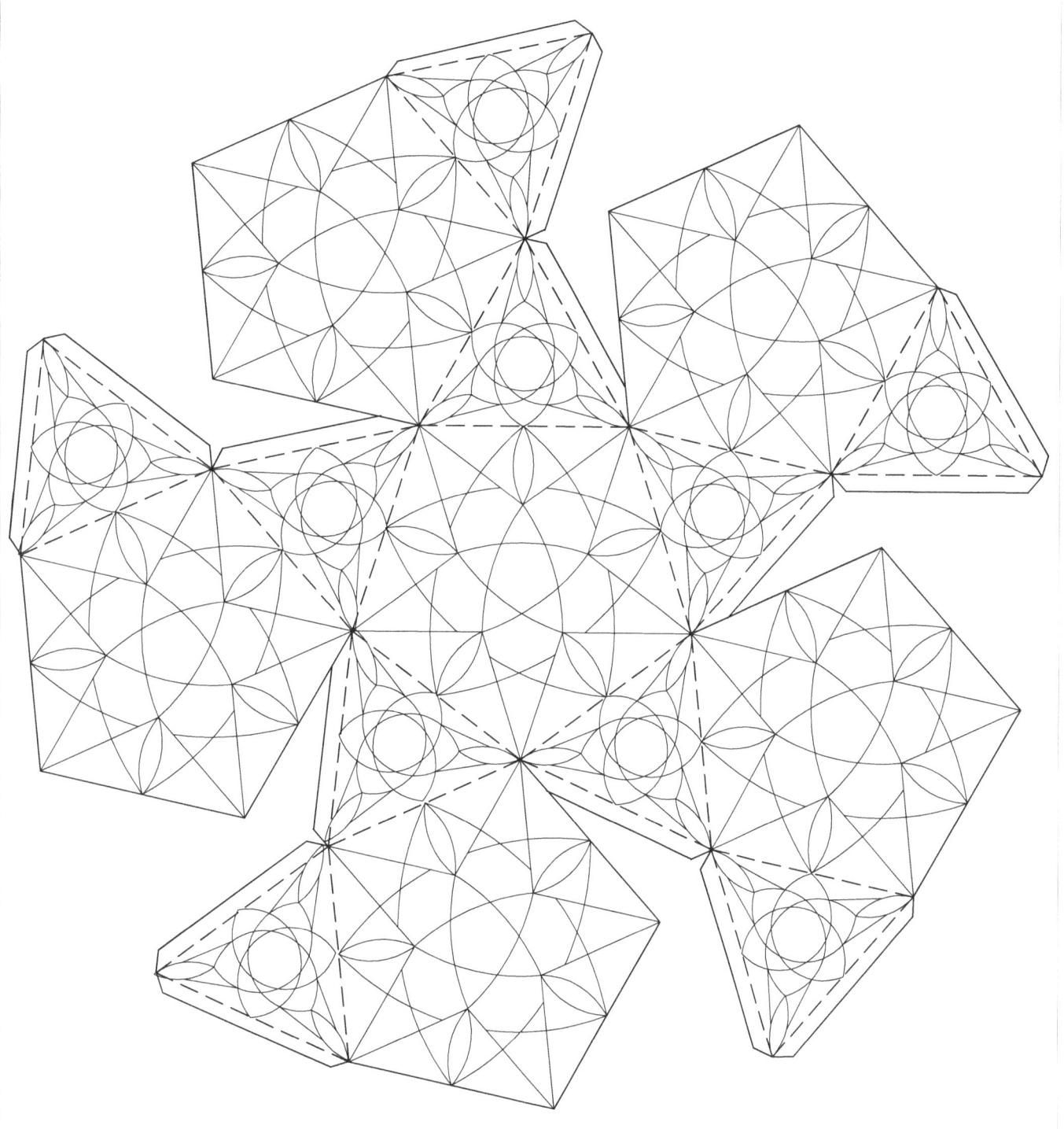

1 Color in both designs from both pages.
2 Cut out both patterns.
3 Tape or glue triangle tabs to pentagons.
4 Tape two halves together with tabs.
Note: Tape will be outside on final junction.

Icosiododecahedron Fold-Up Pattern

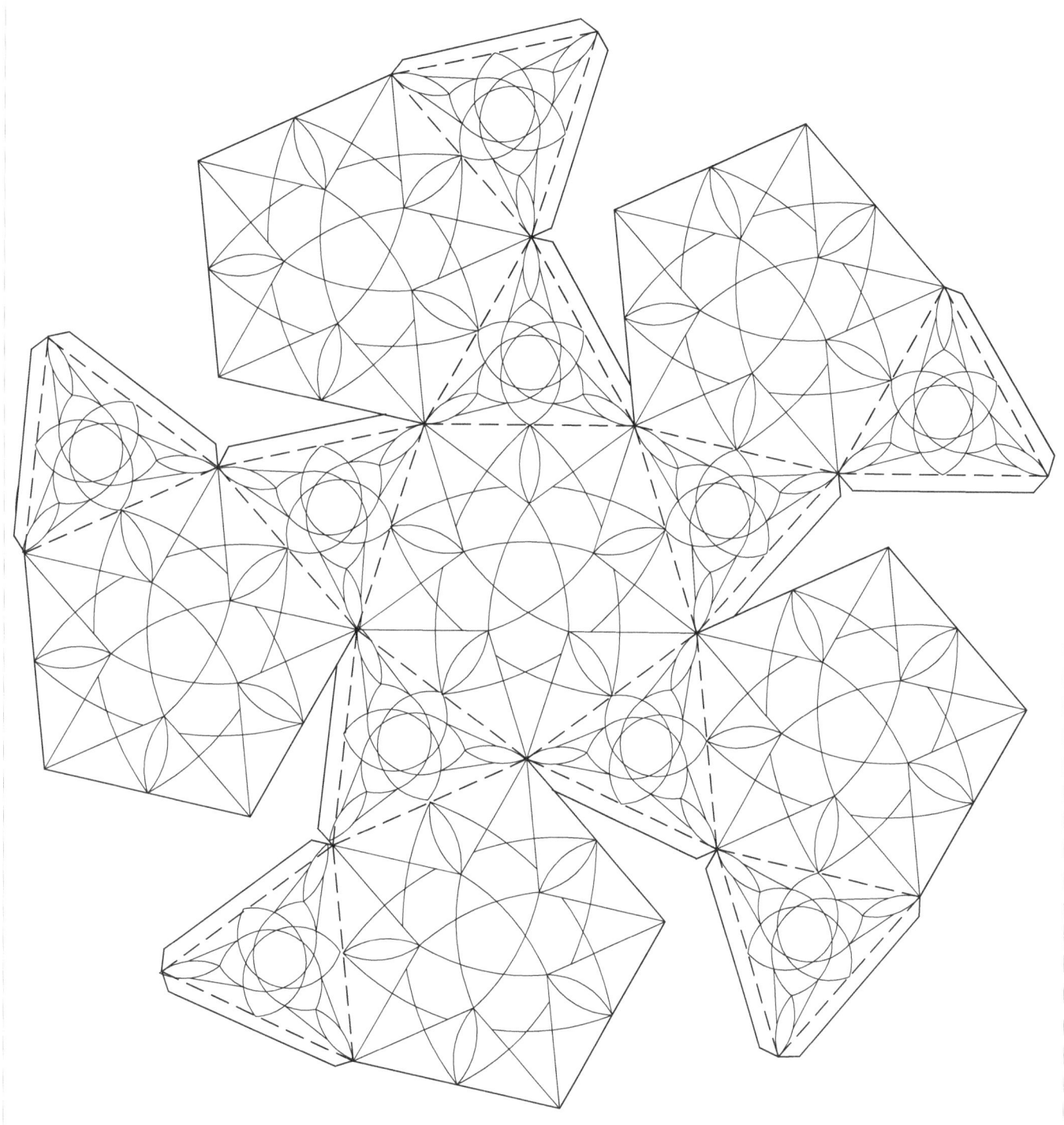

1 Color in both designs from both pages.
2 Cut out both patterns.
3 Tape or glue triangle tabs to pentagons.
4 Tape two halves together with tabs.
Note: Tape will be outside on final junction.

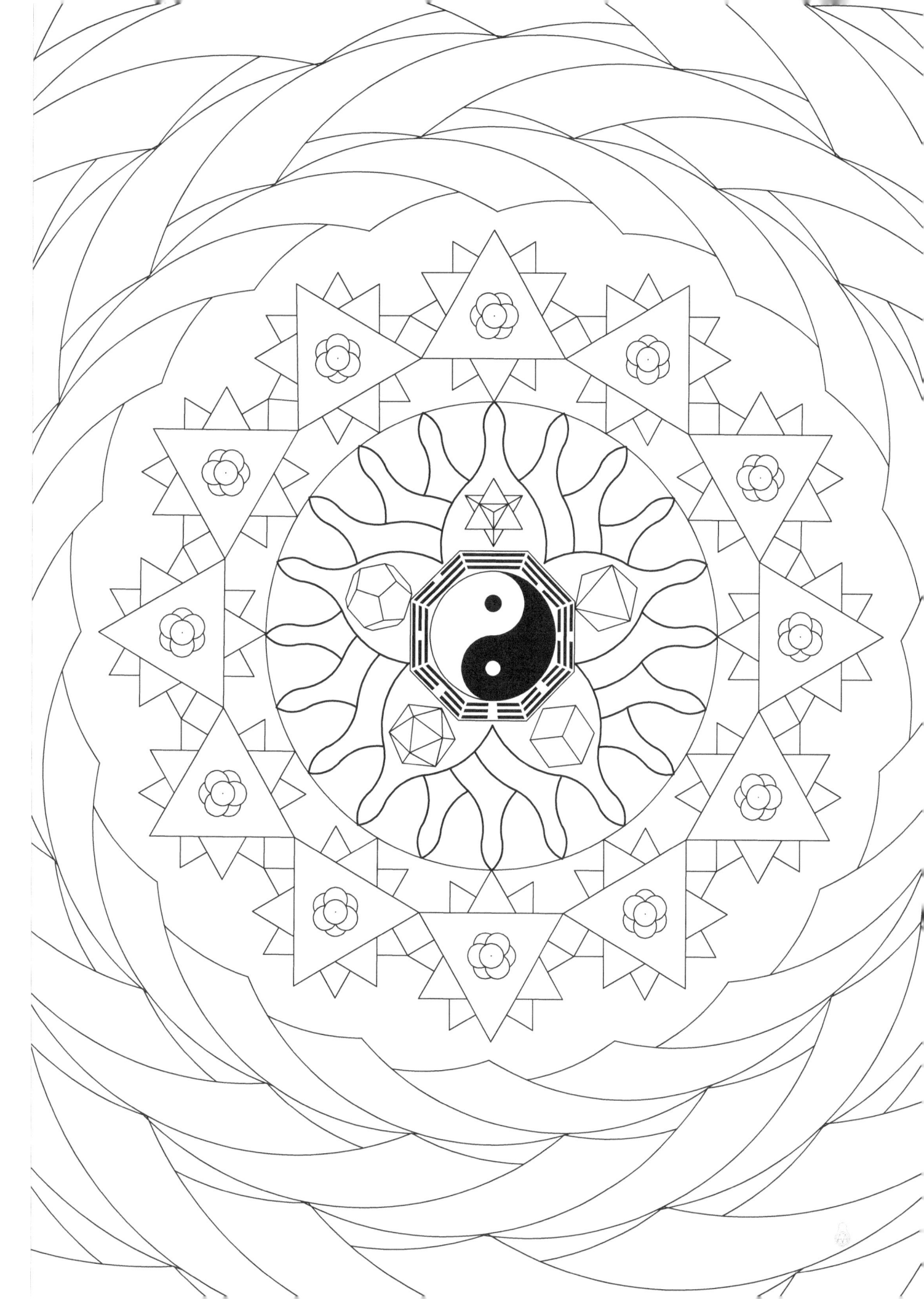

For more information about the art, please visit
meditativegeometry.com

I am Adrian Avocado Andrejeff, and I've been dedicated to sacred geometry since 1996; designing mandalas, geometric foot bag hacky-sacks, and tipi construction; and now create 3D wire wrapped and soldered models of the basic so called "Platonic" solids and many uncommon permutations and love to create light shows.

You can view my videography and photos online. I enjoy sharing teachings, and am preparing a construction manual and online classes for designs and sculptures.

Prints of my mandalas are available for purchase at
meditativegeometry.com

www.ingramcontent.com/pod-product-compliance
Lightning Source LLC
Chambersburg PA
CBHW080538190526
45169CB00007B/2553